Bruegel in Black and White

Three Grisailles Reunited

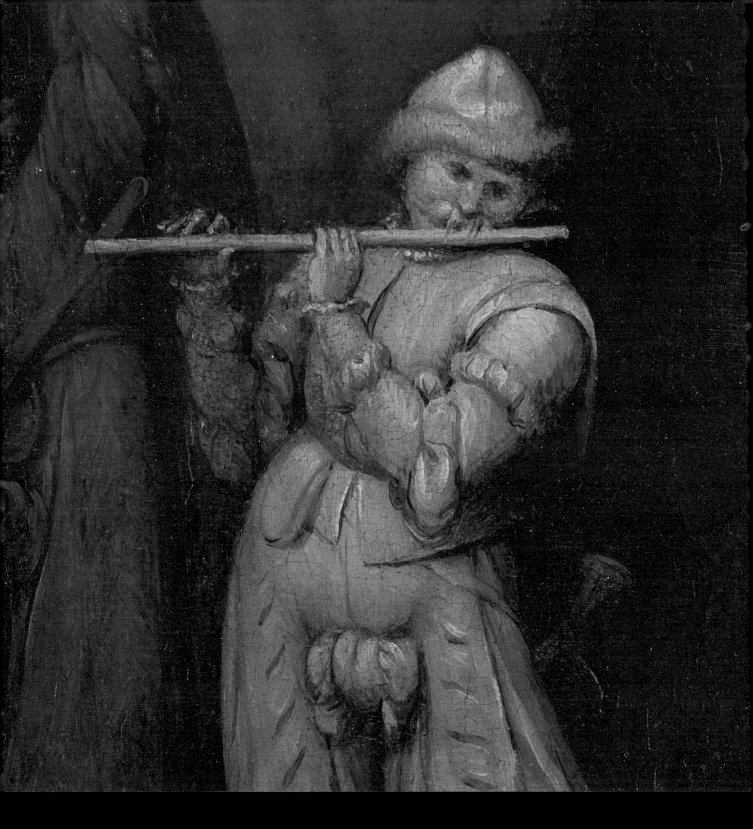

Bruegel in Black and White

Three Grisailles Reunited

Karen Serres

WITH CONTRIBUTIONS BY
Dominique Allart, Ruth Bubb,
Aviva Burnstock, Christina Currie and Alice Tate-Harte

First published to accompany

Bruegel in Black and White: Three Grisailles Reunited

The Courtauld Gallery, London, 4 February – 8 May 2016

The Courtauld Gallery is supported by the Higher
Education Funding Council for England (HEFCE)

HIGHER EDUCATION ***hefce***
FUNDING COUNCIL FOR ENGLAND

ISBN 978 1 907372 94 0

British Library Cataloguing in Publication Data

A catalogue record for this book is available from the British Library

Produced by Paul Holberton publishing
89 Borough High Street, London SE1 1NL
www.paul-holberton.net

Designed by Laura Parker

Printing by Gomer Press, Llandysul

FRONT COVER AND PAGE 7: *Christ and the Woman Taken in Adultery* (cat. 3), detail
FRONTISPIECE: *Three Soldiers*, 1568 (cat. 8), detail
PAGE 8: *The Death of the Virgin*, c. 1562–65 (cat. 1), detail

CONTRIBUTORS TO THE CATALOGUE

DA Dominique Allart
AB Aviva Burnstock
RB Ruth Bubb
CC Christina Currie
KS Karen Serres
AT-H Alice Tate-Harte

Foreword

This focused exhibition brings together for the first time Pieter Bruegel the Elder's three surviving grisaille paintings and considers them alongside closely related works, including near-contemporary copies. Allied to their small scale and evident mastery of a now largely unfamiliar technique, the quiet and pronounced inward quality of these panels presents a fascinating and unknown side of an artist still predominantly associated with paintings of peasant life and Flemish proverbs. The display aims to investigate this little known aspect of Bruegel's oeuvre, with reference also to his circle of patrons and friends and the emergence of grisailles as independent works of art.

Christ and the Woman Taken in Adultery was presented to The Courtauld by Count Antoine Seilern (1901–1978) as part of the Princes Gate Bequest. This great bequest also included the painting *Landscape with the Flight into Egypt* and one of the two drawings by Bruegel that now grace the collection, as well as a group of *naer het leven* ('from life') drawings and sheets depicting panoramic landscapes then thought to be by Bruegel (they are now attributed, respectively, to Roelandt Savery and to the anonymous Master of the Mountain Landscapes). The Courtauld's other autograph Bruegel drawing was presented by Lord Lee of Fareham, who, coincidentally, had owned *The Death of the Virgin* now at Upton and included in the exhbition. The conditions of the Princes Gate Bequest prevent the loan of any painting on panel earlier in date than 1600, meaning that this exhibition could only have happened at The Courtauld Gallery. We are immensely grateful to our colleagues for sharing our ambition and agreeing to lend their precious works.

At the National Trust, special thanks are due to David Taylor, Christine Sitwell, Fernanda Torrente and the staff at Upton House. We are similarly indebted to Xavier F. Salomon and Joanna Sheers Seidenstein at The Frick Collection. Important further loans were made possible by Peter van der Coelen at the Museum Boijmans Van Beuningen in Rotterdam; Mirjam Neumeister and her colleagues at the Alte Pinakothek, Munich; the Fondation Custodia, Paris, especially Cécile Tainturier; the late Willem Baron van Dedem; Emmanuelle Delapierre at the Musée des Beaux-Arts de Caen and Maria Cristina Rodeschini, Giovanni Valagussa and Marina Geneletti at the Accademia Carrara in Bergamo. Technical research forms an important part of this project and we would like to acknowledge the important contributions made by Christina Currie, Dominique Allart, Ruth Bubb, Rachel Billinge, Alice Tate-Harte, Aviva Burnstock and Sophie Scully. For his early advice and encouragement, we are also grateful to Manfred Sellink.

It is a particular pleasure to be able to thank the generous supporters who helped bring this project to fruition – Johnny Van Haeften Ltd, Eijk and Rose-Marie de Mol van Otterloo and the Friends of The Courtauld.

Finally, I would like to extend my warm personal thanks to Karen Serres, Schroder Foundation Curator of Paintings at The Courtauld Gallery. Her discernment and scholarship have resulted in a project that perfectly embodies the character and importance of the Courtauld's programme of focused exhibitions.

ERNST VEGELIN VAN CLAERBERGEN
Head of The Courtauld Gallery

Supporters

Friends of The Courtauld
Johnny Van Haeften Ltd
Eijk and Rose-Marie de Mol van Otterloo

This display has been made possible by the provision of insurance through the Government Indemnity Scheme. The Courtauld Gallery would like to thank HM Government for providing indemnity and extends its thanks to the Department for Culture, Media and Sport, and Arts Council England for administering the scheme.

The position of Curator of Paintings at The Courtauld Gallery is supported in full by the Schroder Foundation. We are immensely grateful to its trustees for their continued generosity.

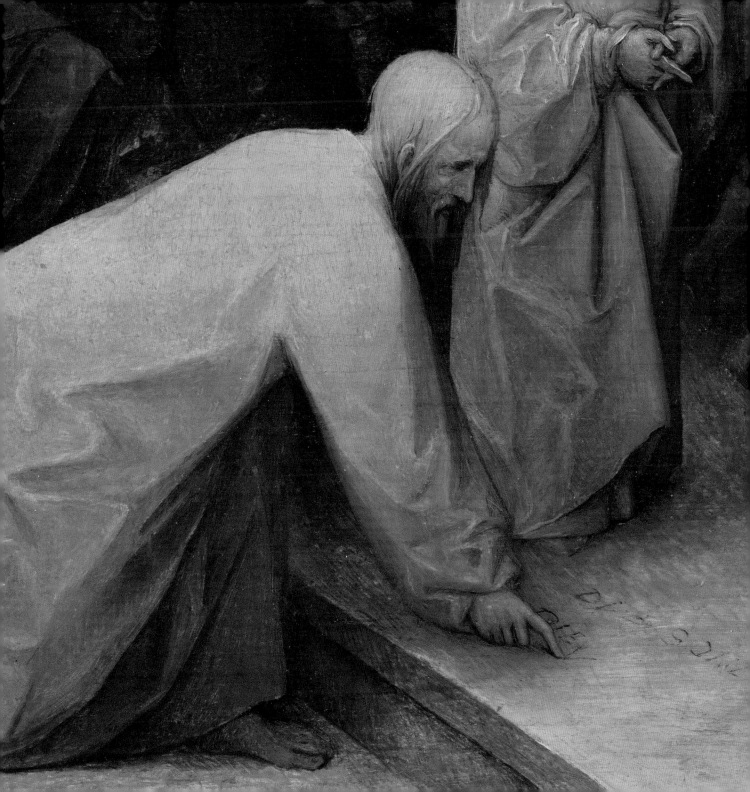

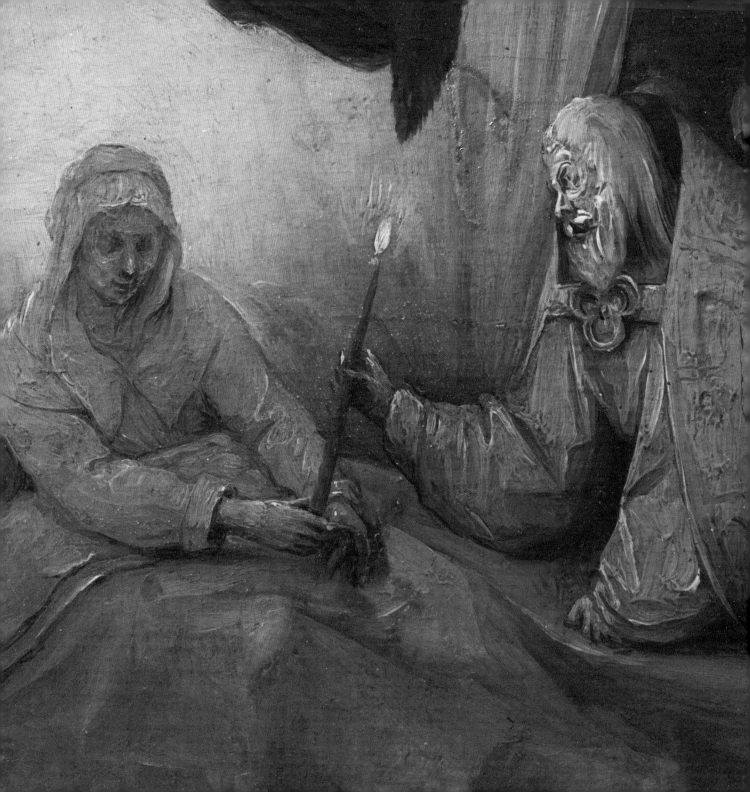

Bruegel's grisailles

Karen Serres

The work of Pieter Bruegel the Elder (c. 1525–1569) is most often associated with panoramic landscapes and village scenes of rowdy peasants, a far cry from the refinement and intimacy that characterise the small panels in shades of grey that are the subject of this publication and the exhibition it accompanies. Bruegel's only three surviving grisailles – *The Death of the Virgin* (cat. 1), *Christ and the Woman Taken in Adultery* (cat. 3) and *Three Soldiers* (cat. 8) – are brought together for the very first time in the exhibition, alongside printed and painted copies, in order to reassess this unfamiliar technique and its context. Recent research and new technical information allow us to consider afresh the creation of these works and their function in the sixteenth-century Netherlands.

Amongst the forty or so paintings currently ascribed to Bruegel, his three grisailles are an anomaly, not only in his production but indeed in Netherlandish painting more generally. Of course, painting solely in tones of grey had been a mainstay of Northern European art since the fourteenth century. It is first found in works of art made for the private sphere, such as precious miniatures and illuminations destined for courtly patrons, and it then moved to church decoration, on the outer wings of large altarpieces and in stained glass.[1] However, it always held a subservient role, as part of a larger ensemble. Indeed, the disparity with neighbouring works of iridescent colour was part of its appeal. In contrast, Bruegel's paintings, as we will see, were conceived as autonomous works of art. They constitute the earliest monochrome cabinet paintings, made for contemplation and personal enjoyment.

Bruegel himself would not have used the term 'grisaille', the earliest mentions of which occur in the early seventeenth century, a half century after his death.[2] Even then, the term was not widely adopted. Bruegel's paintings continued to be described as "painted in black and white" long after their creation, following the standard appellation for this type of monochromatic work since the early Renaissance.

The appeal of 'paintings in black and white' in Netherlandish art was multifaceted, as were the functions they served. One was the capacity to create the illusion of sculpture on a two-dimensional plane, to conjure plasticity and model forms through light and shadow. The illusionistic statues in fictive niches on the outer faces of altarpieces by Robert Campin (such as *The Holy Trinity*, now in the Städel Museum, Frankfurt) or by Jan van Eyck (such as the Ghent Altarpiece or the diptych of *The Annunciation* in Museo Thyssen-

Bornemisza, Madrid) are amongst the earliest and most stunning examples.[3] However, the painters' true objective remains a point of debate: were the muted paintings meant to convey the fasting period of Lent, during which the altarpieces were closed and paintings covered with drapes?[4] Or did they have a more artistic message, playing a role in contemporary *paragone* discussions on the superiority of painting or sculpture?[5]

Indeed, nascent artistic theory of the early Renaissance was greatly concerned with chiaroscuro, the use of grey to depict volume through contrasts of light and shadow.[6] The concept featured heavily in debates on the supremacy of painting over sculpture or of line (also called 'drawing' or 'design') over colour. One of its earliest and most famous formulations can be found in Leon Battista Alberti's treatise *On Painting* (1435–36), which advocates the use of grey (as opposed to pure white or pure black) to create a variety of modulated tones within a composition.[7]

Grisaille underwent an evolution of sorts in the sixteenth century, when it became less illusionistic and more pictorial.[8] Greater emphasis was placed on the range of tonal effects that could be created with monochrome painting. For example, no one could mistake the outer wings of *The Temptation of Saint Anthony* triptych by Hieronymus Bosch (fig. 1) for carved statues or reliefs. Far from seeking a trompe-l'oeil effect, the panels depict crowded scenes from the Passion of Christ that resemble those found on the inside of the altarpiece. Colour simply seems to have drained from the image, leaving only nuanced tonal values (down to the suggestion of Judas's ginger hair, on the left of the panel representing *The Taking of Christ*). The formal links between the group surrounding the captured Christ in Bosch's panel and Bruegel's *Christ and the Woman Taken in Adultery* raise the question of whether Bruegel knew the older master's composition, perhaps through a print

(as he did so many other works by Bosch). Indeed, Bosch's Christ falling to the ground after his arrest is markedly similar to Bruegel's lunging Christ.

This focus on tonality and chiaroscuro meant that grisaille also developed more practical uses, in preparatory oil sketches for paintings and prints. Tonal studies using only mixtures of black and white pigments helped painters to focus on the rendering and distribution of light, to understand where to place highlights and shadows in order to achieve greater depth and modelling.[9] They were an important part of the training of young artists and remained a key step in the painting process.

Such practices were hardly confined to Northern Europe. Grisaille painting was equally embraced in medieval and Renaissance Italy. An early pursuit of trompe-l'oeil effects – creating painted figures to resemble stone statues – can be found in Giotto's frescoes representing Virtues and Vices in the Scrovegni Chapel in Padua (c. 1305). The tradition of fresco painting in grisaille continued both in religious contexts (such as Andrea del Sarto's cycle in the Chiostro dello Scalzo in Florence) and in secular ones. The most famous examples are Polidoro da Caravaggio's great decorative schemes on the façades of Roman palaces in which monochrome friezes imitated classical low reliefs. Andrea Mantegna also engaged with antique reliefs in a series of easel paintings destined for palatial decorative ensembles, representing fictive carved sculpture in grisaille against false coloured marble backgrounds, "art imitating art".[10]

In the Netherlands, however, monochrome painting took on a deeper resonance in the context of the Protestant Reformation and debates on the idolatry of images.[11] Sober and subdued, grisaille painting in the sixteenth century was invested with religious symbolism: it was perceived as deliberately renouncing the seductions of colour to focus on light, a symbol of

1

Hieronymus Bosch
The Taking of Christ and *Way to Calvary*, c. 1500
Oil on panel, 131.5 × 53 cm (each)
Museo Nacional de Arte Antica, Lisbon

the divine. One could interpret the praise bestowed on Bruegel by the theologian Arias Montanus for painting *The Death of the Virgin* "in the most skilful manner and with great piety" in such a context (see cat. 2). The painter's purposeful recourse to only black and white can be seen as a move away from ostentation and as testimony to the aesthetic moderation promoted by contemporary pamphlets and treatises. The grisaille technique imbues the composition with a *gravitas* and solemnity unparallelled in multi-coloured painting.

However, grisailles are too often judged in terms of what they lack (colour) rather than what they allow. Artists chose to paint in grisaille not because it produced a more neutral and duller type of painting, but because of the possibilities afforded by this visual economy. In Bruegel's works, the rendering of light is especially masterful and incredibly seductive, building each form with deep shadows and dotted highlights.

Beyond the visual and cultural traditions in the Netherlands and Italy, Bruegel's turn to grisaille painting can perhaps be traced directly to two formative moments in his career. Bruegel's earliest recorded contract, in 1550, was for the wings of an altarpiece (now lost) for the Cathedral of Saint Rumbold in Mechelen. He was commissioned to paint the outer panels in grisaille, while his contemporary Pieter Balten (c. 1527–1584) was allocated the inner panels, painted in colour. Bruegel's second encounter with the technique of monochrome painting occurred during his stay in Rome in 1553–54. There, he befriended and collaborated

with the famed illuminator Giulio Clovio (1498–1578), who, like his predecessors, made miniatures in grisaille and must have furthered Bruegel's skill as a miniaturist.[12]

Bruegel's three highly accomplished grisaille paintings date from a decade later. *Christ and the Woman Taken in Adultery* and *Three Soldiers* bear autograph dates of 1565 and 1568 respectively. The signed but undated *The Death of the Virgin* shows close technical and stylistic similarities and must date from the same period. All three grisailles were executed in the same manner, which differed significantly from that of previous Netherlandish grisailles:[13] an oak panel of high quality was prepared with a white ground, on which the compositions were first outlined with a charcoal underdrawing. The background was then covered in a thin black wash, with defined areas left white, in reserve. Painting certain figures directly on the white priming rather than on the dark background endowed them with greater luminosity, as was the case for the Virgin in *The Death of the Virgin*, for the four central protagonists in *Christ and the Woman Taken in Adultery* and for the two musicians in *Three Soldiers*. Such reserves prove that Bruegel had carefully worked out his composition beforehand, most probably on a separate scale drawing.[14] This is confirmed by the scarce amount of revisions in the underdrawings (as revealed by infrared photography).

The painting was then built up from the background to the foreground, using only varying tones of grey. The swift execution reveals an assured artist painting almost in shorthand. Bruegel created entire figures with just a few evocative brushstrokes and manipulated the plastic paint at will, for example folding a drop of underlying white paint over a darker area to create a highlight. The pleasure of painting so swiftly must have been a particular attraction of the pared-down technique. The paint is at times so thin as to be transparent and at other times built up to create small areas of impasto that catch

the light (see figs. 8 and 13). All three grisailles would originally have had a much cooler tonality and greater contrast: the discoloration of the ground and varnish is responsible for their slightly sepia appearance.

The confidently rapid execution and restrained palette of Bruegel's grisailles undoubtedly played a role in the view taken by some modern scholars that they could not have been independent finished works of art. As tonal studies had long been used in Northern Europe and Italy as preparatory for a final work of art, the grisailles were often regarded as designs for prints. The compositions of *The Death of the Virgin* and *Christ and the Woman Taken in Adultery* were known long before the rediscovery of the original panels in the mid twentieth century through the reproductive prints made by Philips Galle after *The Death of the Virgin* in 1574 (cat. 2) and Pieter Perret after *Christ and the Woman Taken in Adultery* in 1579 (cat. 4). It thus seemed possible initially that the prints were the final works of art and the panels, made on the same scale, preparatory studies. This idea has long been discarded: the panels do not resemble Bruegel's known preparatory drawings for engravings and, moreover, both prints were made after Bruegel's death. A possible additional indication resides in the fact that they follow the same orientation as the paintings: a preparatory work would have usually taken the need for reversal into account and not depicted, for example, the warrior saint on the mantelpiece in *The Death of the Virgin* holding his sword in his (correct) right hand (fig. 2) nor Christ writing on the ground with his right index finger at the feet of the adulterous woman.

Conspicuously signed and dated in elegant Roman capital letters and numerals, Bruegel's three surviving grisailles must thus be considered as autonomous works of art, made for their own sake. Considering the early owners of these works, they were most likely aimed at the sophisticated viewer, one who was knowledgeable

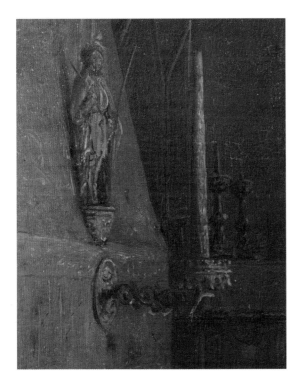

about the painterly process and accustomed to close looking. Certainly, the two enthusiastic testimonies left by visitors after seeing Bruegel's *Death of the Virgin* in the house of the geographer Abraham Ortelius in Antwerp (see cat. nos. 1 and 2) and his decision to distribute prints after it confirm that the small grisaille was held in the highest esteem. The reception of *The Death of the Virgin* and the significant market for copies, especially of *Christ and the Woman Taken in Adultery*, in the late sixteenth and early seventeenth centuries point to their status as precious cabinet pictures. All highly valued, they had a special appeal for connoisseurs and passed through the collections of artists, humanists, cardinals and kings.

Novelty must have also played a part in their appeal. Perhaps surprisingly, the autonomous status of Bruegel's grisailles seems to be without precedent, despite grisaille's long tradition. There are, however, grisailles dating from Bruegel's time that could also be regarded as finished and independent works of art, even if they have not readily been accepted as such. For example, the large panel depicting *The Raising of Lazarus* (fig. 3) by the Antwerp artist Joachim Beuckelaer (c. 1533–1575) is often identified as an oil-sketch design for a print, despite the fact that its wooden support and large dimensions make this function unlikely, as does its very painterly technique.[15] A grisaille representation of a *Virgin and Child* attributed to Jacob de Backer (c. 1540–before 1600) and painted in oil on paper, is said to have "served either as a 'modello' for a painting, a record of a canvas or panel version after it had left the workshop, or a finished painting *sui iuris* that, like the versions on canvas and panel, was sold to a collector".[16] The fact that this work was stuck on to a panel very early on in its history attests that it must soon have gained some measure of autonomy, even if it had not had it from the beginning.

It is difficult to draw general conclusions about Bruegel's grisailles on the basis of no more than three surviving works. However, it seems that the decision to paint a work in grisaille was not linked in any obvious way to its subject-matter. Nocturnal scenes and solemn religious subjects were considered especially suited to the grisaille technique and Bruegel painted one such scene, the Death of the Virgin in her bedchamber. However, he did not reserve grisaille for religious narratives or for night scenes, as *Three Soldiers* attests.

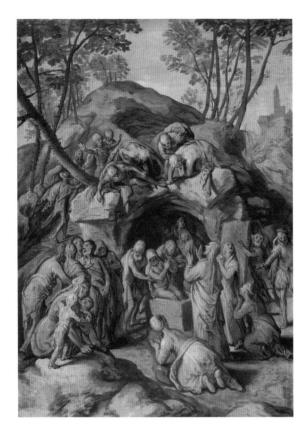

3
Joachim Beuckelaer
The Raising of Lazarus, n. d.
Oil on panel, 72.5 × 52 cm
Fondation Custodia, Lugt
Collection, Paris

great religious strife and biblical representations were never anodyne. Neither was a depiction of mercenary soldiers produced at the onset of the Eighty Years' War. However, Bruegel's own views are difficult to tease out: he poses questions, but does not arbitrate.

The three grisailles had very different fortunes: the two religious scenes were engraved in the decade after Bruegel's death while no copy, either painted or printed, of *Three Soldiers* is known. The prints must have played an important role in the creation of painted reproductions, as almost all of the handful of copies after *The Death of the Virgin* and at least half of the nearly twenty copies of *Christ and the Woman Taken in Adultery* were made after the prints rather than the original panels.

One can justifiably wonder if Bruegel painted additional grisailles, which are now lost. An early seventeenth-century writer describes seeing a *Crucifixion* by Bruegel the Elder, partly painted "in oil in black and white colours" and dated 1559, in the collection of Bartholomeus Ferreris in Leyden.[17] This work is, however, unknown and its attribution cannot be confirmed. In contrast, there is no mention of *The Visit to the Farm* (cat. 9) in early documents but it was purchased as a rare autograph grisaille by Bruegel and remained in his corpus until recently. Though the painting is now attributed to Jan Brueghel the Elder, the question whether the composition reproduces a lost grisaille by the master or is a pastiche invented by one of his sons still divides scholarly opinion.[18] Finally, a large drawing of *The Resurrection* (fig. 4)

What is more, there is no neat separation between Bruegel's grisailles and the rest of his production: the same emphasis on a small group of outsider figures is found both in *Three Soldiers* and in *The Beggars* (Musée du Louvre, Paris), while the close relationship between *Christ and the Woman Taken in Adultery* and *The Adoration of The Kings* (see fig. 15) is explored below (cat. 3). On the other hand, the grisailles' calmer, more restrained character sets them apart in Bruegel's oeuvre, as does the lack of setting and the focus on full-length figures. The grisaille technique can perhaps be said to invite greater meditation on a work and suggests that Bruegel's choice of subject-matter carried special meaning. Bruegel lived in a time of

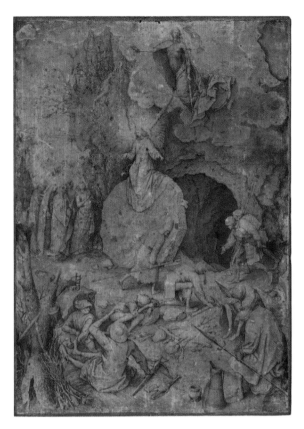

associated with painting, colour. But we must find other ways of assessing this technique, as one that seems fluid across genres. However unfamiliar it seems today, grisaille had a long visual tradition both in Northern and Southern Europe. As he did in many areas, Bruegel extended that tradition in innovative ways. The small-scale panels he created demand that the viewer replace the seductions of colour with those of light but reward close looking with intricate scenes and intriguing subject-matter treated with magisterial skill.

Grisaille remained a multifaceted medium with a complicated status long after Bruegel's innovations. It continued to be used for, amongst other things, trompe-l'oeil architectural decorations and loose preparatory sketches, as well as for stand-alone paintings, during the following centuries.[21] The appeal of monochrome painting endured all the way to the twentieth century. Instead of focusing on its possibilities in the creation of trompe-l'oeil effects or light, however, modern artists harnessed its shocking contrasts: Pablo Picasso's *Guernica* (Museo Reina Sofia, Madrid) and Mark Rothko's *Untitled* (*Black on Gray*) (Solomon R. Guggenheim Museum, New York) are amongst the most powerful examples. Grisaille remains relevant for contemporary practice, for example in Jasper Johns's *Regrets* series, the object of an exhibition at The Courtauld Gallery in 2014.

Bruegel's modest but striking panels marked a turning point in the history of grisaille painting. In their technique and their newfound autonomous status, they played a pivotal role in this long artistic tradition.

was once believed to record another lost grisaille by Bruegel.[19] Indeed, the striking chiaroscuro effects that characterise the composition, which features at least three different sources of natural and divine light, seem particularly suited to the technique. However, this hypothesis has been disproved: with its confident handling of brown ink and wash, the work is certainly autograph and is now widely considered to be an early example of an autonomous drawing, much as Bruegel's grisailles are also stand-alone works of art.[20]

Discussions of grisaille painting often focus on its relationship to other art forms, whether free-standing or relief sculpture, oil sketches or prints; indeed, its very premise is to move away from the quality most

NOTES

References appearing in the notes more than once are given in short form; full details appear in the bibliography at the end of the volume.

1 See Till-Holger Borchert, 'Color Lapidum: A Survey of Late Medieval Grisaille', in *Jan van Eyck: Grisallas* 2009–10, pp. 239–53.

2 The earliest mention may date from 1625, in Claude-Nicolas Fabri de Peiresc's description of the painted copy Niccolò dell'Abate made after an antique cameo as "*en grisaille et non en couleurs*": Marjon van der Meulen, *Corpus Rubenianum. Part XXIII: Copies after the Antique*, London, 1994, 3 vols., II, p. 192.

3 See Michaela Krieger, 'Die niederländische Grisaillemalerei des 15. Jahrhunderts. Bemerkungen zu neuerer Literatur', *Kunstchronik*, vol. 49, no. 12, December 1996, pp. 575–88, and *Jan van Eyck: Grisallas* 2009–10.

4 Molly Teasdale-Smith, 'The Use of Grisaille as a Lenten Observance', *Marsyas*, VIII, 1959, pp. 43–54: this model has increasingly been called into question.

5 See Rudolf Preimesberger, *Paragons and Paragone: Van Eyck, Raphael, Michelangelo, Caravaggio and Bernini*, Los Angeles, 2011, pp. 23–52; *Jan van Eyck: Grisallas* 2009–10, p. 240; and Charlotte Schoell-Glas, 'En grisaille – painting difference', in Martin Heusser, Michèle Hannoosh, Leo Hoek, Charlotte Schoell-Glas and David Scott (eds.), *Text and Visuality. Word and Image. Interactions 3*, Amsterdam and Atlanta, 1999, pp. 197–206. See also Constanze Itzel, *Der Stein trügt: die Imitation von Skulpturen in der niederländischen Tafelmalerei im Kontext bildtheoretischer Auseinandersetzungen des frühen 15. Jahrhunderts*, PhD dissertation, University of Heidelberg, 2003, for the relationship between fictive statues and contemporary debates on the use of images and idolatry. I am grateful to Stephanie Buck for this reference.

6 See René Verbraeken, *Clair-obscur, histoire d'un mot*, Nogent-le-Roi, 1979.

7 See John Gage, *Colour and Culture. Practice and Meaning from Antiquity to Abstraction*, London, 1993, pp. 117–19.

8 See, for example, Paul Philippot, 'Les Grisailles et les "degrés de réalité" de l'image dans la peinture flamande des XVᵉ et XVIᵉ siècles', *Bulletin des Musées Royaux des Beaux-Arts de Belgique*, no. 4, 1966, pp. 225–42.

9 Justus Müller Hofstede, 'Zur Grisaille-Skizze in der Flämischen Malerei des XVII. und XVI. Jahrhunderts', in Rüdiger Klessmann and Reinhold Wex (eds.), *Beiträge zur Geschichte der Ölskizze vom 16. bis zum 18. Jahrhundert*, Brunswick, 1984, pp. 45–58, and Leuschner 2008, pp. 102–03. For a consideration of the topic in Italian art, see Linda Freeman Bauer, *On the Origins of the Oil Sketch: Form and Function in Cinquecento Preparatory Techniques*, Ann Arbor, 1983, and 'Some Early Views and Uses of the Painted Sketch', in Klessmann and Wex 1984, pp. 14–24.

10 *Andrea Mantegna*, exh. cat. ed. Jane Martineau, Royal Academy of Arts, London, and Metropolitan Museum of Art, New York, 1992, pp. 394–400; Keith Christiansen points out that it is fairly certain that Mantegna's "grisailles were not conceived as isolated objects and were not private exercises" (p. 398).

11 Koenraad Jonckheere, 'Images of stone. The physicality of art and the image debates in the sixteenth century', *Nederlands Kunsthistorisch Jaarboek*, vol. 62, 2012, pp. 117–46, and *Experiments in Decorum. Antwerp Art after Iconoclasm*, London and New Haven, 2012.

12 The efforts of Grossmann and Tolnay to attribute miniatures to Bruegel, including grisaille miniatures, have not met with wide acceptance: Charles de Tolnay, 'Further Miniatures by Pieter Bruegel the Elder', *The Burlington Magazine*, CXXII, no. 930, September 1980, pp. 616–23 (with reference to previous articles on the subject).

13 The exception is those of Bosch, which are executed in a similar manner: see *Bosch and Bruegel* 2004.

14 Given its strong similarities in style, composition and scale with *Christ and the Woman Taken in Adultery*, as well as the unusual use of wash, the drawing of *The Calumny of Apelles* (fig. 11) has been proposed as one such preparatory drawing for a lost grisaille painting. However, the presence of Bruegel's signature on a 'working drawing' is surprising.

15 It was executed in a similar technique to the Bruegel grisailles: see Tate-Harte 2006, p. 89.

16 Leuschner 2008, p. 101. Many thanks to Stijn Alsteens at the Metropolitan Museum of Art for suggesting this work, and others.

17 Godefridus J. Hoogewerff and Johan Q. van Regteren Altena (eds.), *Arnoldus Buchelius Res Pictoriae. Aanteekeningen over kunstenaars en kunstwerken, 1583–1639*, 's-Gravenhage, 1928, p. 78; noted by Grossmann 1952, p. 222.

18 Silver 2011, pp. 352–53, for example, believes the work follows a lost grisaille by Bruegel the Elder.

19 Grossmann 1952, p. 221.

20 There is continuing debate whether the atypical blue-gray washes used in the drawing are by Bruegel or later additions. See *Pieter Bruegel the Elder. Drawings and Prints* 2001, pp. 221–24; Sellink 2011, pp. 182–83; Silver 2011, pp. 249–50, and Peter van der Coelen, 'The Resurrection. Pieter Bruegel the Elder', in Yvonne Bleyerveld, Albert J. Elen and Judith Niessen (eds.), *Dutch Drawings from the Fifteenth and Sixteenth Centuries in Museum Boijmans Van Beuningen. Artists Born Before 1581*, Rotterdam, 2012.

21 See *Gray is the Color* 1973–74 and *Pas la couleur, rien que la nuance!* 2008.

Catalogue

1

PIETER BRUEGEL THE ELDER (C. 1525–1569)

The Death of the Virgin, c. 1562–65

Oil on single oak panel, 36.9 × 55.5 cm (max)
Signed on the chest at the foot of the bed: *BRVEGEL*
National Trust, Upton House, The Bearsted Collection, NT 446749

Provenance: Abraham Ortelius (1527–1598); Isabella Brant (1591–1626) and Peter Paul Rubens (1577–1640), Antwerp; Peeter Stevens (1590–1668), Antwerp ; Jan-Baptista Anthoine, Antwerp, 1691(?); Robert Langton Douglas (1864–1951); purchased from him by Arthur Hamilton Lee, 1st Viscount Lee of Fareham (1868–1947) on 30 August 1929 for £6,000; acquired from him in 1930 by Walter Samuel, 2nd Viscount Bearsted (1882–1948); given by him with Upton House and all its contents to the National Trust in 1948

Pieter Bruegel the Elder is known above all for his fantastical creations in the spirit of Bosch and for his peasant scenes. His three surviving grisailles are far removed from these popular themes. This is especially true in the case of the small painting from Upton House, in which the last moments of the life of the Virgin Mary are played out in an atmosphere of intense piety and gravity. In the deathbed chamber, barely lit by a fire in the hearth and several candles, the dying old woman, her face gaunt, raises herself up in bed to receive the taper handed to her by Saint Peter, her gaze fixed on the crucifix at her feet (see facing). As she prepares to take her last breath, she is enveloped in a supernatural halo of brilliant light. Numerous figures emerge from the mysterious shadows and crowd around the bed, their faces marked with fervour and grief. On a chest at the foot of the bed stands a pail of holy water and an aspergillum; Saint Peter, dressed in a priest's cope, will later use them to bless the deceased. The cat curled up before the crackling fire is seemingly unaffected by the sombre mood, just like the young man seated close by, who is fast asleep. This sleeping figure attracts the attention and draws the viewer into the scene.

This intensely emotional and deeply moving nocturne is without a shadow of doubt by the hand of Bruegel, even if the artist's signature on the front of the chest is today almost illegible. The work is also authenticated by Philips Galle's scrupulously faithful engraving (cat. 2), which states explicitly that the model is a virtuoso (*artifice … manu*)

painting (*picta tabella*) and that the author is Bruegel.[1] Moreover, in the last decades of the sixteenth century and in the seventeenth century, several documents mention it, as will be seen later. Indeed, *The Death of the Virgin* is the best documented work by Bruegel that has come down to us.

The small format of the painting is not as much of an outlier in the master's oeuvre as it might at first appear. At about 55 cm wide, it is similar in size to other paintings by Bruegel that invite close contemplation: *The Suicide of Saul* (dated 1562; Kunsthistorisches Museum, Vienna); *Landscape with the Flight into Egypt* (dated 1563; The Courtauld Gallery, London); *The Adoration of the Magi in the Snow* (dated 1563; Dr Oskar Reinhart Collection, Winterthur), and *Winter Landscape with a Bird Trap* (dated 1565; Royal Museums of Fine Arts of Belgium, Brussels). Although no date can be discerned, the Upton House grisaille must date from around 1562–65.

When it was first published in 1930 concomitantly by Ludwig Burchard and Gustav Glück as a rediscovered work by Bruegel, the *Death of the Virgin* was in the collection of Viscount Lee of Fareham.[2] Lee then sold it to Lord Bearsted and the panel has been in the collection of Upton House since 1948, when the house and its contents were gifted by Bearsted to the National Trust.

Although the work had been lost for several centuries, several stages of its early history can be precisely retraced. It once belonged to the famous cartographer, humanist and

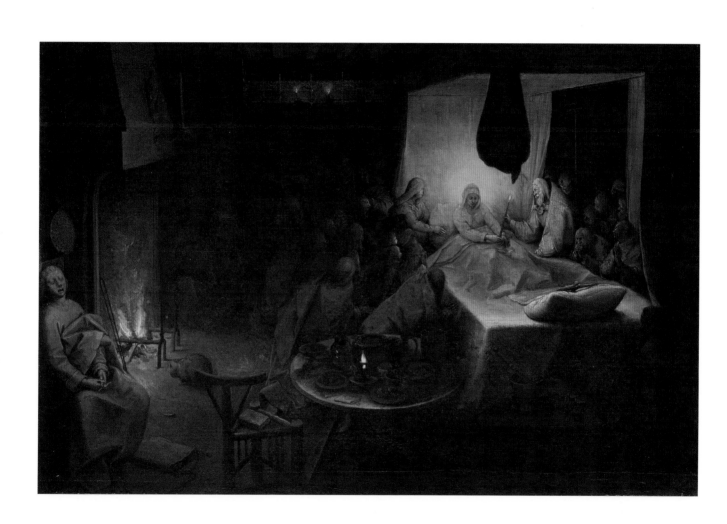

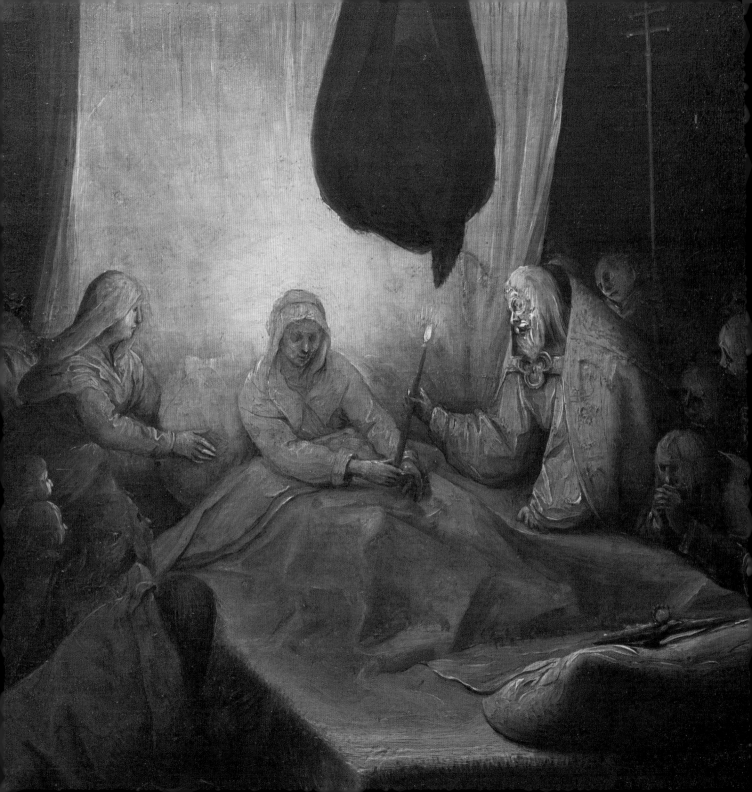

collector Abraham Ortelius, a friend of Bruegel. We do not know how Ortelius obtained it; he may have commissioned it, bought it or received it as a gift from Bruegel himself or acquired it at a later date. In any case, it was in his collection by 1574, when he had the picture engraved by the printmaker Philips Galle in order to offer prints of it to his friends (cat. 2). At that time, Bruegel, who had died five years earlier, was more revered than ever. In the seventeenth century, the painting entered the collection of Peter Paul Rubens and appears in the artist's estate inventory drawn up in 1640: "The death of our Lady, white and black, by Bruegel the Elder".[3] From there, it was acquired by the Antwerp art lover and collector Peeter Stevens, who noted that he owned it in his copy of Karel van Mander's *Schilder-Boeck* (Biblioteca Hertziana, Rome) in the section on Bruegel. Stevens owned many works by the artist, among them *Christ and the Woman Taken in Adultery*.[4] In the inventory of another Antwerp collection, that of Jan-Baptista Anthoine, drawn up in 1691, a "Death of the Virgin" by "Breugel [sic]" is cited, but whether or not it is a grisaille is not mentioned. Since it was estimated at 200 florins, an average price for the Bruegelian works included in this collection, most of which were explicitly attributed to the younger son of Bruegel ("*fluweelen Breugel*"), it is questionable whether this citation corresponds to the painting in Upton House; it could refer to a version of the composition by one of Bruegel's sons.[5]

The theme of the Death of the Virgin has given rise to an abundant iconography in Byzantine and Western art. An engraving by Marten Schongauer (fig. 5) and a woodcut by Albrecht Dürer (fig. 6) are among the works that Bruegel could have known and emulated.[6] Like them, Bruegel abstained from showing the physical apparition of Christ and the angels coming to collect the soul of the

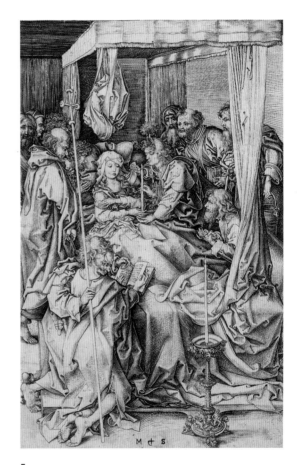

5
Marten Schongauer
The Death of the Virgin, c. 1470–74
Engraving, 25.9 × 17.1 cm
The British Museum, London

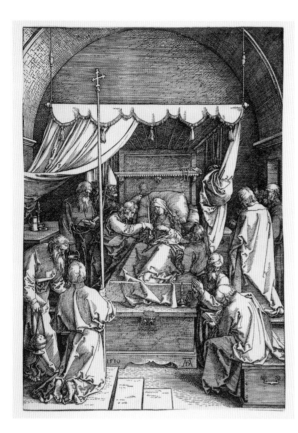

6

Albrecht Dürer
The Death of the Virgin, 1510
Woodcut, 29.3 × 20.5 cm
The Metropolitan Museum of Art,
New York

children. Furthermore, the use of strong contrasts between light and shade – chiaroscuro – plays an essential role in the composition, which is depicted as a night scene. It is possible that Bruegel was aware of miniatures such as the one in the Grimani Breviary (fig. 7), which shows a dying person in a room cloaked in darkness where tapers introduce contrasts in lighting. The effect anticipates that perfected by Bruegel in his grisaille.[8] In the image by Bruegel, however, the light of the candles and the fire connect with the supernatural light that seems to emanate from the Virgin herself. Glück rightly underlines that "never before the work of Rembrandt was such a spiritualization of light aimed at, and even achieved, as in this delicate little grisaille painting".[9] The mystical and emotional suggestion is all the more compelling since the scene takes place in an ordinary domestic setting, filled with objects and utensils referring to daily routines.

As noted above, the young man dozing near the fireplace catches the viewer's attention. He has given rise to considerable commentary, most of which considers him to be Saint John the Evangelist.[10] But no-one has convincingly explained why Christ's preferred disciple, whom he asked to take care of his mother, would then be shown sleeping at the crucial moment of Mary's death.

The episode of the Virgin's Death, not recorded in the Bible, was popularised by apocryphal texts and sermons. It is well known that Chapter 115 of the much read *Legenda Aurea* by Jacobus de Voragine was the principal textual source of its iconography in Western art at the end of the Middle Ages. However, the text has perhaps not been read with all the attention it merits. In this rather long chapter, Jacobus successively relates several traditions regarding the Death and Assumption of the Virgin. One more than the others offers a better understanding of certain peculiarities

Virgin, as favoured by pictorial tradition (for example, in the well-known version by Hugo van der Goes in the Groeningemuseum, Bruges). Bruegel could also have borrowed from Schongauer or Dürer the figure of the Apostle holding out a taper to Mary, but in his version the Apostle is Peter rather than John.[7] From Schongauer, he reprises the diagonal arrangement of the canopied bed. He owes the motif of the chest at the foot of the bed to Dürer and signed his name in the same location as Dürer had placed his monogram.

Bruegel's version of the theme surprises us nonetheless by its novel features. As Glück already observed in 1930, in other occurrences of this iconography the mourners are always limited to the Apostles. In Bruegel's picture a large anonymous group is present, including women and

7

Gerard Horenbout or Simon Bening
The Death Chamber, 1510s
The Grimani Breviary, fol. 449v
Biblioteca Marciana, Venice

attendants, with the exception of the Apostles and three virgins, were plunged into a deep sleep. It was at that point that Jesus arrived with the angels to collect the soul of his mother. At that precise moment, the Virgin radiated a light so vivid that the Apostles could no longer look at her. The other members of the assembly awoke just after Mary expired.

Bruegel's picture is most likely meant to evoke the very moment before the miraculous event of Christ's coming to take Mary's soul, according to this version of the story. This would explain why the attendants were not limited to the Apostles: Mary's family members and friends are also present.[12] The young man dozing near the fireplace could allude to the sleep that would soon overcome part of the audience; that is to say, two successive parts of the account would be condensed. John is featured on the right, at the feet of the Virgin, as explicitly mentioned in the source; indeed, it is possible to recognise his beardless youthful face. The supernatural light starting to radiate from Mary's body heralds the imminent miracle. In the play of chiaroscuro, the importance given to the glimmers of several candles can also be explained by the text of Jacobus de Voragine. According to the same tradition that he attributes to Cosmas Vestitor, Mary advised Saint Paul, who was also present, not to extinguish the lamps as long as she was still alive.

As some have remarked, the presence of a crucifix at the foot of the bed and the emphasis on Saint Peter in the guise of an officiating priest followed by a person carrying a double-barred processional cross are signs of a religious orthodoxy that, if not that of the artist, must have been that of the patron, whether Ortelius or not. Moreover, it is hard to imagine that Ortelius would have been so profoundly attached to the painting had he been a free thinker or

of the Bruegelian version. It ensues from homilies that Jacobus attributes to Cosmas Vestitor, but which in fact come from the *Sermo de Assumptione beatae Mariae* by Johannes Aretinus.[11]

According to this variation of the story, the Virgin, informed of her imminent death by an angel, gathered all her friends and relations around her. The attendants were numerous; Jacobus de Voragine mentions the presence of no less than 120 virgins. Saint John arrived by chance, whereas the other Apostles were miraculously transported to the deathbed chamber. Saint John told them the news proclaimed by the angel. They dried their tears, paid their last respects and worshipped Mary, who took to her bed. The text specifies that Peter was placed at her head and John at her feet. Following a clap of thunder, the gathered

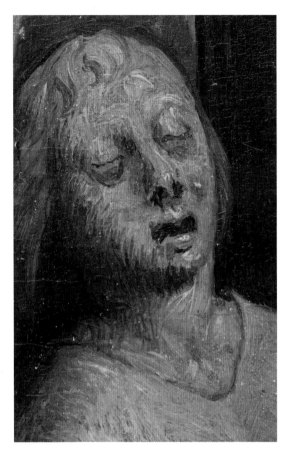

'figure' characteristic of a premium radial cut. The finish is smooth, which is typical of Flemish panels, and plane marks are visible in the direction of the grain. Tree-ring analysis (dendrochronology), carried out by Ian Tyers, identified an eastern Baltic origin for the wood.[16] The single board is unusually wide for this region – 36.9 cm – the usual widths being between 25 cm and 32.5 cm. According to the analysis, the tree was felled after c. 1552. Tyers shared the tree-ring data with Pascale Fraiture, a dendrochronologist based in Belgium who had taken part in a wider study on Bruegel's techniques and materials published in 2012.[17] Fraiture was able to deduce that the board comes from exactly the same tree as another identically sized panel by Bruegel, *Winter Landscape with a Bird Trap*, signed and dated 1565. The dendrochonological study undertaken on the Brussels panel proved that the tree it originated from was cut down no earlier than 1553. Given that the National Trust board comes from the same tree, the same *terminus post quem* applies. Interestingly, Tyers recently discovered that the single oak board used for Bruegel's *Landscape with the Flight into Egypt*, signed and dated 1563 (The Courtauld Gallery, London), also derives from this same tree.[18]

The oak panel was most likely first sized with animal glue, to reduce its porosity. It would then have been ready to receive the preparatory layers, also known as priming. The ground layer is white and extends to the edges of the original panel. Its purpose would have been to smooth out any irregularities in the panel support and to provide as smooth a surface as possible on which to paint. Although no analysis was undertaken, it is likely to be chalk in a glue medium, as in other sampled paintings by Bruegel[19] and indeed most sixteenth-century panel paintings in northern Europe. Bruegel most likely sealed his porous ground with an oiling-out layer. This may have been tinted with lead

member of the heterodox sect of Hendrik Niclaes, as some have supposed.[13]

The caption of Galle's engraving describes its model as "*artifici picta tabella manu*" (this picture, painted by a skillful hand). Indeed, the *Death of the Virgin* serves as a perfect example of Bruegel's technique and of the extraordinary virtuosity of his brushwork.[14]

Bruegel selected a quarter-sawn oak board of excellent quality on which to paint the *Death of the Virgin*. This judicious choice has ensured that the panel is still in excellent condition more than four hundred years after its manufacture.[15] The wood grain is closely spaced and the reverse of the panel displays an attractive pattern or

white, as what appear to be the white grains of lead soaps are visible in certain areas of thin paint.[20] Lead white would have acted as a drier on the oil and enhanced the whiteness of the ground.

Bruegel kept the paint layer deliberately thin so as to allow his white underlayer to shine through and provide the light tones. But before he even started to paint he would have first drawn on his design. Underdrawing lines are visible here and there in the infrared reflectogram and are sometimes perceptible with the naked eye.[21] They are applied in a friable medium such as black chalk or charcoal, as in *Winter Landscape with a Bird Trap*. They are most visible where Bruegel made minor changes to the design. One such spot is the bed cover of the Virgin. Here, the initial project for the folds has not been followed in paint. Other motifs adjusted during drawing include the profile of the Virgin's female attendant and the firedogs. Then during painting the artist shortened the furthermost andiron, presumably to avoid disrupting the portrayal of the flames. Given the complex, multi-figural composition of the *Death of the Virgin*, and the fact that there are no significant differences between the underdrawing and painting stages, it is likely that Bruegel made a detailed independent preliminary sketch before he started.

Following his underdrawing, Bruegel applied a layer of dark grey or black background paint first, leaving spaces for the forms to come, working from the background through to the foreground. The leaving of reserves was an essential step for establishing the carefully modulated tonal harmony of the composition, as this enabled him to exploit his light underlayer as a tone. Reserves would also have prevented the formation of drying cracks.

Bruegel balanced his tones according to the natural and supernatural sources of light, namely the Virgin's halo, the candles and the fireplace. He worked up his figures in shades of grey, finishing them off with light grey highlights and black touches. In certain still-life motifs, he avoided the use of the lightest grey completely, merely tinting his ground with translucent black or thinly applied opaque grey paint in order to create the lighter tones. In several motifs, such as the Virgin's halo, the uppermost lamps and Saint Peter's face, the paint contains large amounts of a blue pigment or pigments, giving a variety of grey hues.[22]

For the sleeping youth on the left, Bruegel literally 'sculpted' the face in one session, starting with the grey mid tones and then working up the contours using increasingly dark grey and black strokes (fig. 8). Lighter grey highlights are judiciously blended with the previous strokes. Translucent black strokes establish the deeper shadows such as the nostrils and mouth, but also define the shape of the closed eyes. Saint Peter's face is painted with equally audacious brushwork: again, working wet-in-wet on pale grey, the artist rapidly dashed off the eye sockets, nose and mouth using a well-loaded brush and black and white paint, adding the beard, hair and cope clasp at the same time.

One of the most virtuoso passages is the group of attendants praying to the right of the Virgin's bed. Again, in what appears to be one sitting, Bruegel established the mid tones in opaque grey paint, defined certain forms and outlines in black, and then indicated highlights in a series of rapid and perfectly accurate strokes, deftly adding structure to faces, hands and drapery folds. Particularly impressive is his effortless handling of foreshortening.

Finally, the motif of the crucifix at the foot of the Virgin's bed is a tour de force of painting and economy of means (fig. 9). In just a few black strokes and light grey dabs, Bruegel establishes the crowned head and outstretched arms, while just to the left of the head two simple dabs

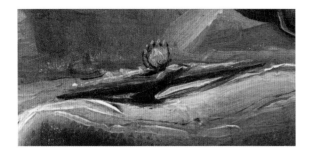

indicate the feet. The viewer's imagination fills in the rest.

Bruegel made just a few minor adjustments during painting.[23] The left shoulder and right arm of the Virgin's attendant were shifted upwards, while the hand patting the pillow was brought down. The perspective of the tester was modified, probably to increase the sense of foreshortening. During painting, the cat was shifted downwards and slightly left of its reserve; the artist had even started to paint the darkest part of the fur before he changed his mind.

Bruegel's signature is located at the lower right, near the bottom of the chest before the Virgin's bed. It is now invisible to the naked eye but can be made out with magnification. Although "indistinct traces of a date" after the signature were mentioned in the 1964 catalogue of the Bearsted collection, none could be found on either side of the chest.[24] Given that the panel support derives from the same tree as that used for the 1565 *Winter Landscape with a Bird Trap* and that *Christ and the Woman Taken in Adultery* (cat. 3) is also dated 1565, it seems reasonable to assume that the painting was executed in the mid 1560s.

Bruegel may have inadvertently left his fingerprint in the paint, at the foot of the andiron near the cat. It does not appear to serve any aesthetic function, unlike others in Bruegel's paintings, such as *Winter Landscape with a Bird Trap*, in which a fingerprint lightens the corner of a hole in the ice.[25]

"*In omnibus eius operibus intelligitur plus semper quam pingitur*" (In all his works, there is always more meaning than he painted): Ortelius probably had his treasured *Death of the Virgin* in mind when he wrote these laudatory words in a posthumous panegyric he included in his *Album Amicorum* (c. 1574; Pembroke College Library, Cambridge).[26]

Indeed, in this painting, Bruegel conveys profound feelings without the usual external markers. He makes the sacred mystery of Mary's miraculous reunion with her Son all the more emotive since he does not try to depict it as a physical phenomenon. Ortelius's statement also celebrates Bruegel's vivid brushwork, which alludes to, rather than describes, the crowd around the deathbed.

Five painted versions of the composition have been identified, all probably executed relatively early. They lack the intense gravity of the model, since they are all painted in full vibrant colour.[27] Their authorship is not certain, although one of them, a small painting on copper, is signed *P. BREVGHEL*, suggesting that it may have been produced after 1616 by Pieter Brueghel the Younger, the elder son of Pieter Bruegel the Elder and his assiduous copyist.[28] The four other known copies comprise a further copper panel of similar dimensions and three wooden panels, all of different formats. Four of the five copies were certainly made after the engraving rather than the original painting.

It is surprising that Brueghel the Younger, who sometimes painted dozens of copies after his father's compositions, did not exploit the *Death of the Virgin* for serial reproduction. For example, many more copies after *Christ and the Woman Taken in Adultery* (cat. 3) have come down to us. Brueghel the Younger would certainly have been aware of the composition through the engraving, if not the original painting itself, which he could have seen in his youth at Ortelius's house and, later on, in Rubens's collection. Had he decided to include the theme among his stock subjects, he would have kept to a standard format, developed a cartoon, and no doubt produced many copies. Perhaps he did not consider the theme sufficiently commercial, or felt that its serious tone was incompatible with his own more anecdotal style. DA, RB & CC

2

PHILIPS GALLE (1537–1612), AFTER PIETER BRUEGEL THE ELDER

The Death of the Virgin, 1574

Engraving (second state of two), 33 × 43.8 cm (sheet)
Example exhibited: Museum Boijmans Van Beuningen, Rotterdam, inv. no. BdH 2793
Example reproduced here: British Museum, London, inv. no. 1874,1212.449

Provenance: Acquired at auction at C.G. Boerner, Leipzig, 2 May 1923 by Dr J.C.J. Bierens
de Haan (1867–1951); bequeathed by him to the Museum

Abraham Ortelius was particularly proud to possess *The Death of the Virgin*, an exquisite masterpiece unsurpassed in its power of suggestion. The engraving he commissioned from Philips Galle in 1574 was a means of sharing the pleasure he derived from the painting with his friends, as implied by the inscription in the lower margin.[1] The Latin verses, perhaps composed by Ortelius himself, offer a compelling contemporary comment on the meaning of the picture. They emphasise its emotional aspect, stressing the mixture of joy and sadness felt by the attendants witnessing Mary's final moments before rejoining her Son.

It is no coincidence that the cartographer solicited Philips Galle for the engraving. They both lived in the Lombardenvest in Antwerp at the time and were close friends. Philips Galle proved himself worthy of Ortelius's trust. In this large-format print, executed in the same orientation as the model, he laid out Bruegel's composition in meticulous detail, sensitively completing passages where the original was indistinct. The result is a portrayal of the scene that faithfully renders the original design, yet in a more descriptive manner. The only divergence that he allowed himself was the rectification of the perspective of the chair in the foreground: in Bruegel's painting, the chair is deliberately distorted, to create a link between the sleeping figure in the left foreground and the rest of the composition. Galle took great care to translate the chiaroscuro of the scene into a subtle network of hatching and cross-hatching. The result of his efforts is a masterpiece, "one of the best prints he ever made".[2]

Some of the recipients of the prints were similarly impressed. On 15 July 1578, the Haarlem humanist, engraver and poet Dirck Volckertsz. Coornhert (1522–1590) sent a letter of thanks to Ortelius in which he praised both Bruegel and Galle for surpassing themselves. He wrote that they had created an atmosphere of such deep sorrow that not only his eyes but also his ears were touched. Once again, the emotional aspect of the image was emphasised, as well as the two artists' ability to suggest contrasting feelings: "the room appears funereal", Coornhert wrote, "and yet, it seems to me that everything is alive".[3] Later on, in a letter dated 10 April 1591, another friend of Ortelius, the Spanish Benedictine scholar Arias Montanus (1527–1598) acknowledged receiving prints of Galle's engraving. Previously, on 30 March 1590, he had asked Ortelius for a reproduction of a painting he had probably seen first-hand during his stay in Antwerp between 1568 and 1575. He described it as "painted in the most skilful manner and with great piety".[4]

A pen-and-ink drawing of the composition should also be mentioned in this context (fig. 10).[5] Though anonymous and of somewhat mediocre quality, it is interesting since it is thought to have been retouched by Rubens, who may have introduced the brown wash and white highlights. It is difficult to say whether it was initially executed after the painting or the engraving. The distortion of the chair

10

suggests the former. But, as Kristin Lohse Belkin observes, a point "in favour of the drawing having been copied from the print is its (unusually) large size, which is almost the same as the print".[6] An alternative hypothesis is that a faithful drawn copy was made after the painting when it was in Ortelius's collection, by Galle or one of his draughtsmen, in order to facilitate the execution of the engraving. The Louvre sheet could be a copy of this drawing. In any case, if the retouching is indeed by Rubens, as the experts have confirmed, it would bear witness to the interest that the great Baroque master had in the superb composition of his predecessor.[7] DA, RB & CC

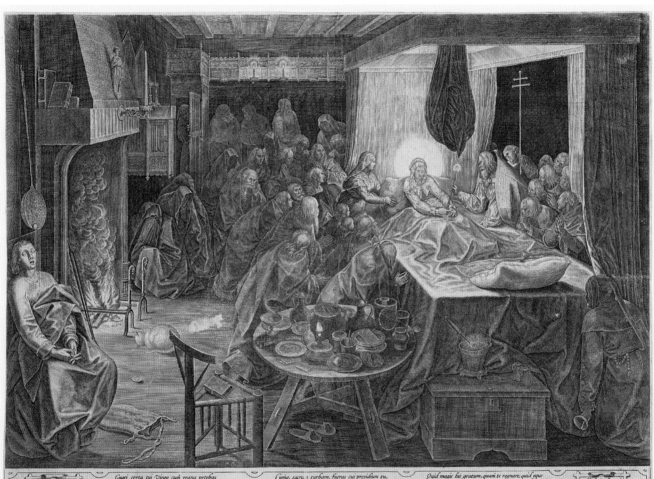

3

PIETER BRUEGEL THE ELDER (c. 1525–1569)

Christ and the Woman Taken in Adultery, 1565

Oil on single oak panel, 24.1 × 34.4 cm
Signed and dated lower left: *BRVEGEL.M.D.LXV*
The Courtauld Gallery, London, P.1978.PG.48

Provenance: Bequeathed by Jan Brueghel the Elder to Cardinal Federico Borromeo, Milan, in 1625; returned by Borromeo to Jan Brueghel the Younger, Antwerp; Peeter Stevens, Antwerp;[1] his sale, Antwerp, 13 August 1668, lot 14;[2] Henri van Halmale, Bishop of Ypres (1625–1676); Robert Hampden-Trevor, 1st Viscount Hampden (1706–1783; ambassador to the Netherlands from 1739 to 1746); by descent to Jane-Maria, Viscountess Hampden (d. 1833); her sale, Christie's, London, 19 April 1834, lot 61, sold for 10 guineas; acquired by Alexander Hope, Luffness (Scotland); by descent; sale of the collection of Major Alexander P.J. Hope, Christie's, London, 1 February 1952, lot 60, bought for £11,025 by Dr Alfred Scharf "acting on behalf of a friend on the Continent"; Count Antoine Seilern, London; bequeathed to the Home House Trust (later Samuel Courtauld Trust) as part of the Princes Gate Bequest in 1978

Christ and the Woman Taken in Adultery depicts an episode of the life of Christ recounted in the Gospel of John (8:1–11): a crowd had gathered around Jesus outside the Temple to listen to his teachings when a group of Pharisees and Scribes brought to him a woman who had recently been condemned for adultery. According to the Scriptures, her punishment should be stoning. Seeking to catch Jesus dismissing Jewish law, the Pharisees asked for his opinion on the sentence. Without a word, he knelt on the ground and wrote in the dust: "He that is without sin among you, let him first cast a stone at her". This compelling command was enough to disperse the crowd and save the woman.

Dressed in sixteenth-century attire, the condemned woman stands at the centre of the composition, her hands wrung in front of her and her two index figures stretched long (see also fig. 13). The sleeping figure on the left in *The Death of the Virgin* (cat. 1) and the allegorical figure of Penitence in *The Calumny of Apelles* (fig. 11) both make a similar gesture, which can thus perhaps be interpreted as a gesture of penance or sorrow. The woman's body faces the Pharisees but she turns her head towards Christ, who has lunged forward and traces with his right index finger a sentence on the platform marking the entrance to the Temple. Two rocks are strewn on the ground, an allusion to the woman's assigned fate. On both sides of the composition, groups of figures lean in to read Christ's words. Behind him is the crowd of his disciples while the group on the right is composed of the Scribes and Pharisees coming from the Temple. They are led by two striking figures: one, wearing a tall cap, hunches down and gestures towards Christ. The other, sporting a long beard, looks on impassively, his hands tucked into his heavy robes. The girdle book hanging from his belt and the pseudo-Hebraic inscription running along the bottom border of his robe (now abraded) identify him as a Jewish scholar. The adulterous woman herself seems to stand in a clearing as the figures around her turn away and disappear into the shadows. Thus Bruegel has conflated three moments of the narrative into one scene – the duplicitous solicitation of Christ's opinion (embodied by the Pharisee's rhetorical gesture); Christ's silent response; and the sparing of the woman's life as the executioners disperse.

Bruegel's representation manages to be monumental on a small scale. The painter has multiplied the figures –

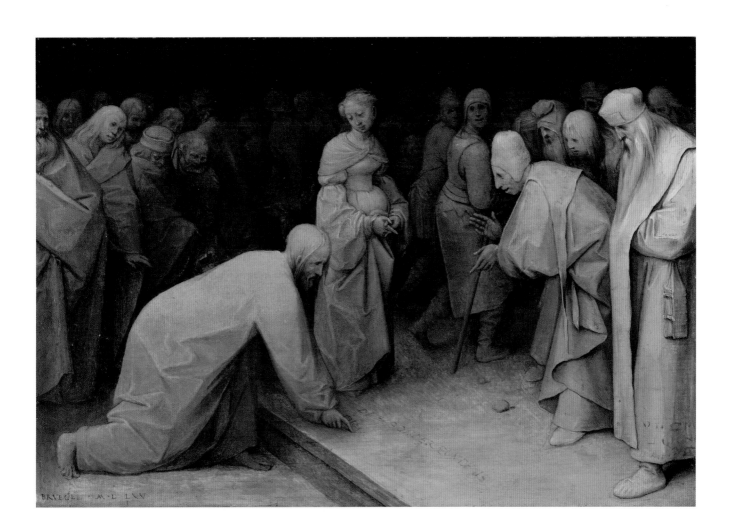

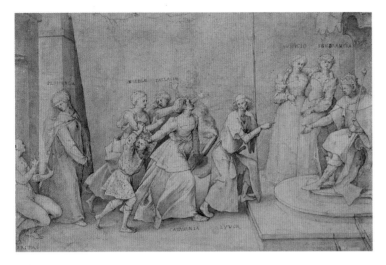

11

Pieter Bruegel the Elder
The Calumny of Apelles, c. 1565
Pen and brown ink with brown
wash, 20.2 × 30.6 cm
The British Museum, London

most of them heads with no corporeal presence – within a constricted space to give the sense of an unruly crowd. This creates a striking contrast with the clearing at the centre of the composition, the eye of the storm. The main figures are aligned in the foreground, in the manner of a low relief. Christ and the two Pharisees are rendered in profile and face one another. The black background adds to this feeling of enclosure, one that is only slightly alleviated by the sense of depth created by the bisecting step on to the platform and by the small figures dispersing into the distance. The biblical narrative places the episode out of doors, at the entrance to the Temple, but there is little to indicate an open-air setting.

The picture is not only monumental but also highly sculptural thanks to Bruegel's chosen technique of grisaille. The spare use of pigments, limited to lead white and carbon black (with some red and brown iron oxide) over a warm grey preparatory layer, allows the painter to focus on the effect of light falling on the figures. Some, such as the commanding figure on the right, seem spotlit while others only painfully emerge from the shadows. The light hits Christ's left shoulder but the rest of his body is harder to discern.

The limited palette meant that the painter was able to paint quickly, achieving swift calligraphic effects.[3] The technique is sophisticated: many areas have been reworked while the paint was still wet, using a fine brush to apply and to remove wet paint from the layers below to create highlights. The touch is extremely confident, with few changes visible. The most significant one is revealed by the infrared reflectogram, which shows that Bruegel drew the old Pharisee's right sleeve using carbon black but decided not to paint it in the end, perhaps to shift the emphasis on to the figure's posture in relation to the stooping figure behind him.

As in his other grisailles, Bruegel first applied a ground of chalk bound in animal glue, followed by a thin scumble of lead white (and possibly red lead) in an oil medium. This would have saturated the ground and reduced its absorbency. The support is a single panel of oak imported from the Baltic and cut by a specialised panel maker.[4] The panel, which has retained its original thickness, is expertly bevelled on the right and left sides on the reverse. The general outline of the composition was then drawn over the white priming. An unusual feature of *Christ and the Woman* is the presence of two types of underdrawing. An initial drawing in red chalk, traced freehand (rather than transferred), broadly defines the contours but seems to have been adhered to only loosely in the final painting.[5] Traces of this are now visible on the surface, owing to the

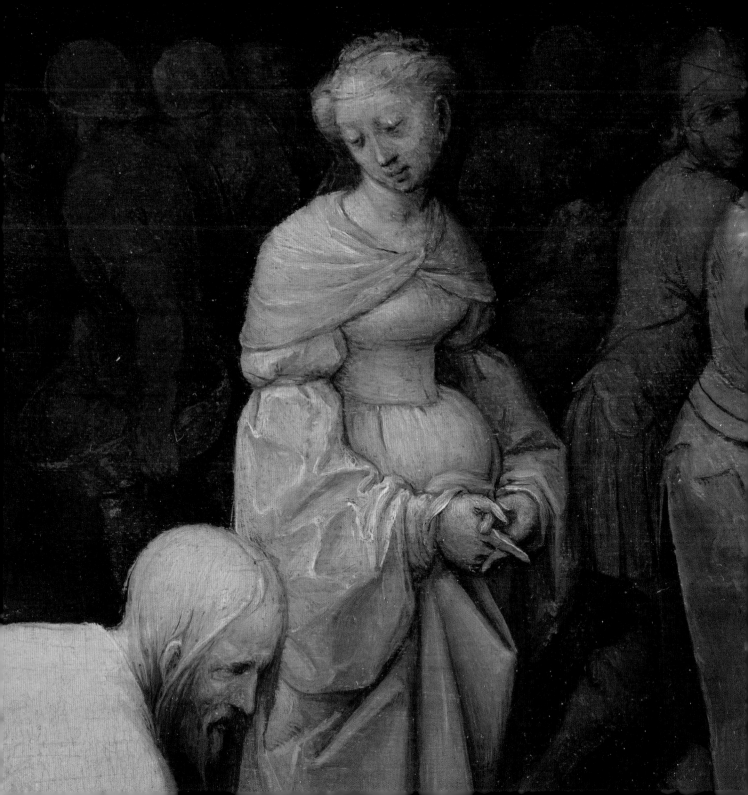

12, 13

Details of the foot of the hunched Pharisee,
showing red and black underdrawing, and the
hands of the woman, showing slightly thicker
paint application to create raised highlights

increased transparency of the overlying paint, for example around the foot of the hunched Pharisee (fig. 12). Its specific purpose remains unclear, although red may have been chosen because it provided a good contrast to the black and white layers to come. This unusual type of underdrawing was followed by a second, more characteristic underdrawing in a dry carbon-black medium, probably charcoal. The black underdrawing, visible in the infrared photograph, is relatively precise and includes some hatching to indicate areas of shadow.

The four main figures were left in reserve; painted very thinly in light grey directly over the white ground, they appear more luminous than their neighbours. The idiosyncratic modelling of their robes, which resemble carved marble, was achieved by adding and wiping away dilute mixtures of warm grey paint, composed of black and white pigments complemented by a small amount of red earth, to create the shadows and highlights. A few particles of the blue pigment azurite were added to the paint mix for the robes and flesh of the main figures, in order to impart a cooler tone. The paint is at times applied a little more thickly to create areas of low impasto (fig. 13). A build-up of lead white around the edges of the main figures is visible in the X-radiograph, covered in the final stages by the reinforcement of their outlines and features in black paint.

Representations of Christ and the Adulterous Woman are found in both Italian and Netherlandish painting, by artists as varied as Ortolano, Lorenzo Lotto, Tintoretto, Lucas Cranach and Pieter Aertsen. While patrons appreciated the empathetic theme, it offered artists the opportunity to represent a crowded gathering and a variety of figures. Pieter Aertsen (1508–1575), Bruegel's Antwerp-based contemporary, depicted the theme at least twice, a few

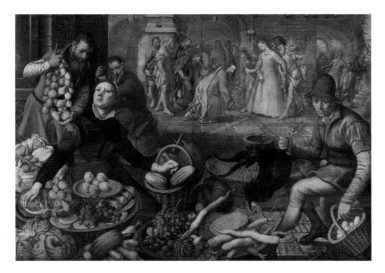

14

Pieter Aertsen
*Christ and the Woman Taken
in Adultery*, 1557–58
Oil on panel, 122 × 178 cm
Nationalmuseum, Stockholm

years before Bruegel's grisaille, always in the context of representations of market stalls (fig. 14). His figure of Christ lunging forward may have influenced Bruegel's composition.[6]

In most of these compositions, artists struggled to depict the inscription traced by Christ, often foregoing it altogether. Its presence and scale in Bruegel's composition are anomalous and suggest deeper connotations. Written in Dutch rather than the more historically accurate Hebrew or prevalent Latin, it was clearly meant to be understood by Bruegel's contemporaries. The writing covers a large section of the light-filled foreground, which is otherwise bare except for the rocks at the feet of the hunched Pharisee. Christ is halfway through tracing the words, which read: "*DIE SONDER SONDE IS, DIE ...*" (He that is without sin, let him ...). Any literate viewer would have been able to complete the sentence: "*WERP DEN EERSTEN STEEN*" (cast the first stone).

The painting's intimate scale and delicate execution call for close looking and personal reflection. This singular representation of a biblical plea for clemency and introspection has most often been interpreted as a veiled allusion to the contemporary religious crisis in the Netherlands and an appeal for tolerance.[7] Religious and political tensions in the Spanish-controlled Southern Netherlands had been brewing for many years and culminated in a series of iconoclastic attacks in the summer of 1566, a year after this panel was painted. Attempts to pinpoint Bruegel's own religious views, and whether they were expressed in his art, have remained inconclusive. The artist worked both for Catholic patrons close to the Spanish rulers and for declared Protestants. It is thus most likely that Bruegel was moderate and pragmatist, as was his circle of friends in Brussels and Antwerp.

The unusual format of the composition, with its multitude of figures pressed to the foreground, has led scholars to perceive an Italian influence.[8] Bruegel was in Italy from 1551 to 1554, travelling as far south as Calabria and working in Rome with the miniaturist Giulio Clovio. However, ten years later, when he was working on his grisaille, his sources must have been reproductive prints. Raimondi's prints after Raphael's *Acts of the Apostles* cartoons have been proposed as a possible influence, although Bruegel could also have had seen copies of the cartoons in Brussels, where the tapestries were woven. It is, however, telling that, when discussing the possible inspiration for the bearded Pharisee with his hands tucked in his robes, Grossmann hesitated between Andrea del Sarto's large

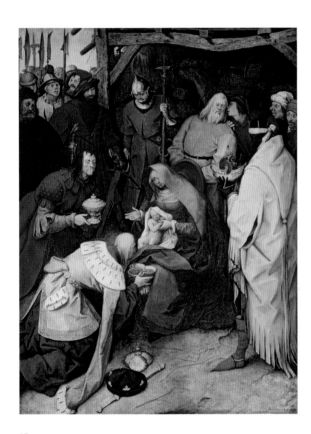

15
Pieter Bruegel the Elder
The Adoration of the Kings, 1564
Oil on panel, 112.1 × 83.9 cm
The National Gallery, London

grisaille fresco of *The Preaching of Saint John the Baptist* in the Chiostro dello Scalzo in Florence and its source, Dürer's distinctly Northern print of *Ecce Homo*.[9] As in the rest of Bruegel's oeuvre, the influence of Italian art was heavily mediated.

In fact, the composition and the figures find an echo in Bruegel's own oeuvre. The relief-like format, shallow composition and dynamic movement from left to right echo his *Calumny of Apelles*, dating from the same period (fig. 11). The motif of the two figures with lifted heels to indicate movement (on the left of the drawing) recurs in reverse in the grisaille panel. Furthermore, the clothing of the adulterous woman recalls that of the allegorical figure of Suspicio in that same drawing, while her features closely resemble those of the Virgin in *The Adoration of the Kings* (figs. 15, 16, 17). Despite the difference in size, the latter must have influenced the composition of *Christ and the Woman Taken in Adultery*. Dated a year earlier, it is a rare instance of a crowded composition seen up close, with the multitude of large-scale figures obscuring any perspective or sense of depth. As in the grisaille, the composition is built around an empty space in the foreground. The kneeling King on the left recalls the lunging Christ of Bruegel's grisaille while the towering figure of the black King on the right echoes the Pharisee. In addition, there are similarities in technique: the King's heavy fringed white coat and the grey garment worn by Joseph standing behind the Virgin are built up with thin layers of white and grey paint, in a manner we find also in the grisaille.

Although nothing is known of the context of the creation of *Christ and the Woman Taken in Adultery*, the fact that it remained with the family after Bruegel's death indicates it may have been made for the painter's personal enjoyment and contemplation. The painting is thus extremely unusual

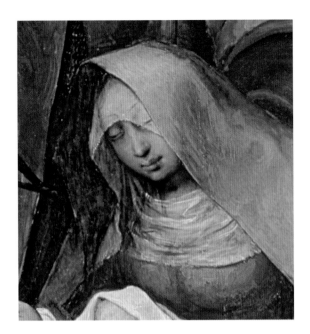

16
Detail of the Virgin in fig. 15

17
Detail of the Woman Taken
in Adultery in cat. 3

in the fortune of Pieter Bruegel's oeuvre: it was one of the few to have been copied directly by his sons, as attested by Jan Brueghel's delicate panel now in the Alte Pinakothek in Munich (cat. 5) and Pieter Brueghel the Younger's copy in colour (cat. 7).[10]

In 1625, Jan bequeathed the panel to one of his most important patrons, Cardinal Federico Borromeo in Milan, and it was duly sent to Italy.[11] In the end, however, Cardinal Borromeo deemed the gift too generous and sent it back to the family, although not before commissioning a copy for himself (cat. 6). He had the painting refitted in an ebony frame, adorned with silver ornament and an inlay inscription acknowledging the gift and return.[12] The work was probably sold the following year by Jan Brueghel the Younger.

The composition was extremely popular from an early date: more than eighteen painted copies of it are known (at least eleven in grisaille, seven in colour).[13] It was engraved in 1579 by Pieter Perret (cat. 4) and the prints published in Antwerp and Amsterdam. The paint surface bears a series of pin pricks at regular intervals,[14] made while the paint was still plastic. Their purpose remains unclear. Scholars have speculated that they were used by Perret as an aid to the engraving or by Jan for his copy, but they are too numerous to create a practical grid as the squares would have been too small.[15]

Christ and the Woman Taken in Adultery arguably displays an unprecedented level of refinement in Bruegel's oeuvre, in its technique, constricted composition and modelling of the figures. The numerous copies attest to the popularity of the design but also reinforce, by contrast, the virtuoso handling of paint that Bruegel demonstrates in this grisaille.
AB, KS & AT-H

4

PIETER PERRET (1555–1639), AFTER PIETER BRUEGEL THE ELDER

Christ and the Woman Taken in Adultery, 1579

Engraving (second state of two), 26.7 × 34 cm (sheet)
Inscriptions: *P BRVEGEL M D LXV/ P Perret f 79/ C. J. Vißcher excudit/ Cum Privilegio*
QVI SINE PECCATO EST VESTRUM, PRIMUS IN ILLAM LAPIDEM MITTAT. Ioan 8.
The Courtauld Gallery, London, G.1978.PG.81

Provenance: Count Antoine Seilern, London; bequeathed to the Home House Trust
(later Samuel Courtauld Trust) as part of the Princes Gate Bequest in 1978

This print by the Netherlandish engraver Perret bears the date of 1579, making it one of the earliest known engravings by him. It was executed shortly before he left Antwerp for Italy and Spain, where he spent the rest of his career. The print is known in two states: the first bears the address of the Antwerp publisher Pieter de Jode while the second was published in Amsterdam by Claes Jansz. Visscher. The second state also bears a correction in the inscription traced by Christ on the ground: whereas the first state follows the strange spelling of the first word, which a faint horizontal line apparently turns into *DVE* in the original panel, the second state corrects this to *DIE*, the correction on the plate rendering the *I* markedly darker.

Interestingly, the print is the same size and in the same orientation as the original panel. The presence of pin pricks at regular intervals on Bruegel's painting has led to speculation that the marks were made by a compass and used to position a tracing paper in preparation for the full-scale engraving.[1] However, an engraver would have been able to make a reproductive print without recourse to such a large number of marks or to the tight grid system they seem to suggest. KS

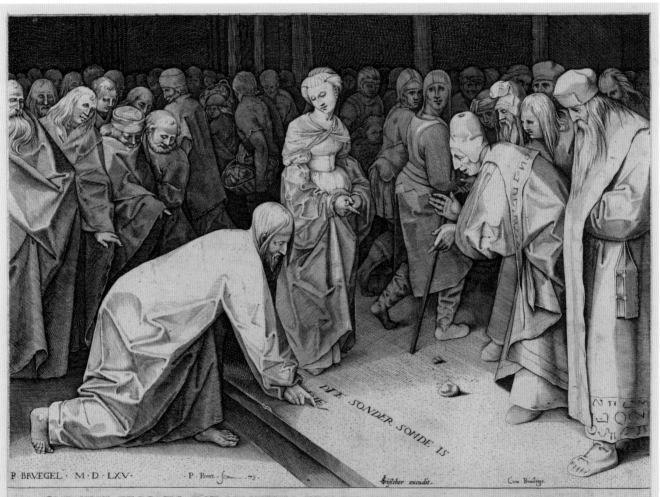

P·BRVEGEL·M·D·LXV· P·Perret·fecit·79· Fischer excudit· Cum Priuilegio·

QVI SINE PECCATO EST VESTRVM, PRIMVS IN ILLAM LAPIDEM MITTAT. Ioan. 8.

5

JAN BRUEGHEL THE ELDER (1568–1625), AFTER PIETER BRUEGEL THE ELDER

Christ and the Woman Taken in Adultery, c. 1597–98

Oil on oak panel, 23.7 × 36.4 cm
Bayerische Staatsgemäldesammlungen, Alte Pinakothek, Munich, inv. no. 1217

Provenance: Recorded in 1799 in the Bavarian princely collection in Mannheim; transferred to Munich

Unlike his brother Pieter the Younger, Jan copied only a limited number of his father's paintings and drawings before embarking on a different artistic path. *Christ and the Woman Taken in Adultery* was a work he knew intimately, because, as he stated in a 1609 letter, it was the only painting by Bruegel the Elder still in the family (see cat. 6) and he was thus able to copy it directly.

He chose a slightly more elongated format, heightening the frieze-like appearance of the composition. The empty space in the foreground is reduced, placing the viewer closer to the biblical figures and to the inscription, which comes right up to the lower edge of the panel. Jan has also delineated much more meticulously than his father the features of the more than three dozen figures present in the composition, using a thin black outline. Whereas Bruegel the Elder used pure white highlights sparingly, the light is much more forceful in Jan's treatment, as entire figures are rendered in thin white brushstrokes. This emphasis on a greater plasticity of the figures means that every figure is visible and competes for the viewer's attention, lessening the impact of the central group. KS

6

LOMBARD PAINTER (?), AFTER PIETER BRUEGEL THE ELDER

Christ and the Woman Taken in Adultery, c. 1625

Oil on panel, 26.4 × 34.8 cm
Inscribed lower left: *BRVEGEL M.D.LXV*
Accademia Carrara, Bergamo, inv. no. 58 AC 00254

Provenance: Cardinal Federico Borromeo, Milan(?); Giacomo Carrara (1714–1796);
bequeathed to the Accademia Carrara in 1796

In his extensive correspondence with Jan Brueghel the Elder, whose work he collected and championed, Cardinal Borromeo had long expressed the desire of securing a painting by Jan's father. A letter dated 6 March 1609 from Jan apologizes for not being able to satisfy this request: no works by his father were available, since Emperor Rudolf II had spared no expense in securing them all.[1] He mentions, however, a last painting still in the family's hands, *"un quader de sua man con ciaer e scura"* (a painting by his [father's] hand with light and dark) and promises to send drawings of it. In the end, the painting stayed in Antwerp until Jan's death in 1625 but was on route to Milan by August of that year, Jan having bequeathed the painting to Borromeo in his will.[2] Despite his eagerness to own a work by Bruegel the Elder, Borromeo refused the gift, which he deemed too generous, and returned the panel to the family. Before doing so, however, he commissioned a copy for his museum.

A copy that has been preserved for two and a half centuries in Bergamo, the only known copy of Bruegel's panel kept in Italy, may be the work commissioned by the cardinal. It faithfully follows the composition, although the handling of paint is quite crude and does not reproduce the fine modelling of the robes. The figures feel rather lifeless and less monumental. In addition, the shaky signature and inscription are awkwardly fitted in a compressed foreground.

Borromeo considered that copies served an important didactic function and commissioned a number of them for his library and museum. Thus, he had copies of frescoes and altarpieces by Raphael, Leonardo da Vinci, Bernardino Luini and Correggio, among others. In certain cases, copies were even deemed preferable to the originals, as they provided an opportunity to modify and reinterpret certain compositions, most often transforming secular images into religious ones.[3] Borromeo employed a number of copyists and, in the absence of documentation, it is impossible to know which local painter copied Bruegel's original.[4] KS

7

PIETER BRUEGHEL THE YOUNGER (1564–1638), AFTER PIETER BRUEGEL THE ELDER

Christ and the Woman Taken in Adultery, 1628

Oil on panel, 27 × 37.5 cm
Signed and dated lower left: *P. BREVGHEL 1628*
Private collection

Provenance: Von Hilten collection before 1961; sold at Galerie Fischer, Lucerne, 26 June 1962, lot 2019; Brod Gallery, London; Mrs Roose, Antwerp; Charles De Pauw, Brussels; his sale, Sotheby's, London, 9 April 1986, lot 18; private collection, Germany; sold at Carola Van Ham, Cologne, 28 October 1999; Johnny Van Haeften Ltd, London, where purchased by the current owner in 2000[1]

Pieter Brueghel the Younger made a career of copying his father's work. At least four versions of this composition are signed by him but this work is the only one that also bears a date. By 1628, the original grisaille on which this coloured copy was based was probably no longer with the family, although Pieter the Younger could have relied on his previous copies, drawings and the print as guidelines. In fact, scholars have long presumed that Pieter the Younger based all of his copies not on the original but on Perret's engraving, which offered greater clarity.[2] This seems confirmed by the striped cloth worn by the adulterous woman to cover her hair, a feature that is absent from the original grisaille but that was used by the engraver to animate that light and otherwise flat section of the engraving.

The application of a lively palette to the grey composition transforms it in two fundamental ways. One, deliberate on Pieter the Younger's part, was to clarify the setting and set each figure apart. The contours are more clearly defined, as are the columns in the background, locating the scene more firmly outside the Temple. The other consequence, perhaps less intentional, is that the main drama is diluted by the lack of modulation of light and the integration of the four central figures with those in the background. The result is a toning down of the spiritual resonance of the representation and of its forceful message. KS

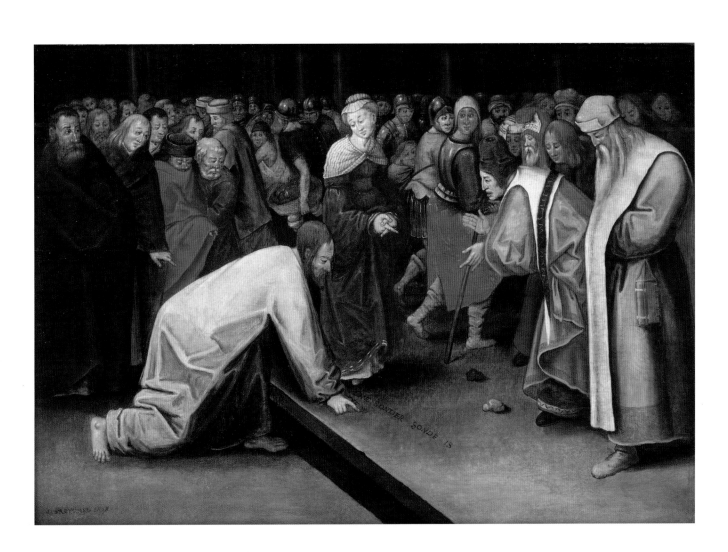

8

PIETER BRUEGEL THE ELDER (c. 1525–1569)

Three Soldiers, 1568

Oil on single panel (probably oak), 20.3 × 17.8 cm
Signed and dated lower left: *BRVEGEL M D [L] XVIII*
The Frick Collection, New York, 1965.1.163

Provenance: Given by Endymion Porter to Charles I before 1640; sold at the Commonwealth sales, 1 February 1652/53, to "T. Greene"; returned to Charles II at the Restoration; British royal collection, by descent until 1714; William van Huls, Whitehall, London; his estate sale, 6 August 1722 and following days, lot 60; private collection, England, from about 1900 until the 1950s; purchased by Mr Marks, antiques dealer, c. 1960; Christie's, London, 26 June 1964, lot 6, sold for £24,150 to Edward Speelman, Agnew's and one other dealer; purchased by the Frick Collection, 1965[1]

This small panel represents three men against a dark background, all absorbed in their activity. Two are playing a musical instrument: the figure on the left, his back to the viewer, holds a snare drum while the figure on the right, in an elegant contrapposto pose, plays the fife. Between them, emerging from the darkness, is a standard-bearer. He reaches his left arm to raise the standard and looks up at the flag. The sword across the front of his body follows his extension and points upwards toward the standard. This short sword, called a *Katzbalger*, with its distinctive sinuous crossguard, was the instrument of choice of mercenaries from Germany known as *Landsknechte* and became closely associated with them in visual representations.[2] It was worn horizontally at the waist and used in close combat.

The extravagant costume worn by the three soldiers also identifies them as mercenaries, who were exempt from the sumptuary laws prevailing in Germany. An elaborate, Spanish-style doublet with swelling sleeves, slashed to reveal the shirt underneath, is complemented by long, billowing hose and an ostentatious codpiece. In addition, the fifer wears a jerkin, a sleeveless garment most often made of leather and added over the doublet. He has opted for a simple fur-lined hat, in contrast to the drummer, who sports an ornate feathered beret. A thin linen net, of which the bulging edges are visible, covers his hair and keeps the hat in place.

Created in emulation of the Swiss mercenaries at the end of the fifteenth century, the *Landsknechte* formed a professional army that waged war throughout Europe for the highest bidder, most often the Holy Roman Emperor or the King of Spain. They were at the peak of their power and reputation in the early sixteenth century but were still active in Bruegel's lifetime. Although soldiers appear frequently in his oeuvre (as in *The Massacre of the Innocents*, *The Conversion of Saul* or *The Sermon of Saint John the Baptist*, which features two colourfully dressed mercenaries in the foreground), his focus on these three elegant figures is unusual. The representation clearly stems from knowledge of the highly popular prints of military men produced in the Netherlands and Germany by artists such as Barthel Beham and Jacob Binck (fig. 16). Most date from the first half of the sixteenth century but evidently still circulated widely in the latter part of the century.

These prints present the mercenaries in a variety of ways, echoing their multi-faceted perception by society as a whole. Their itinerancy and flamboyance fuelled moralizing satire and mockery but also the lifestyle also seemed attractive and escapist. Their colourful costumes and dangerous profession cast them as figures to be, all at once, admired, scorned and feared. Indeed, mercenary soldiers were a common sight in Germany and the Netherlands during the sixteenth century: they inspired dread during

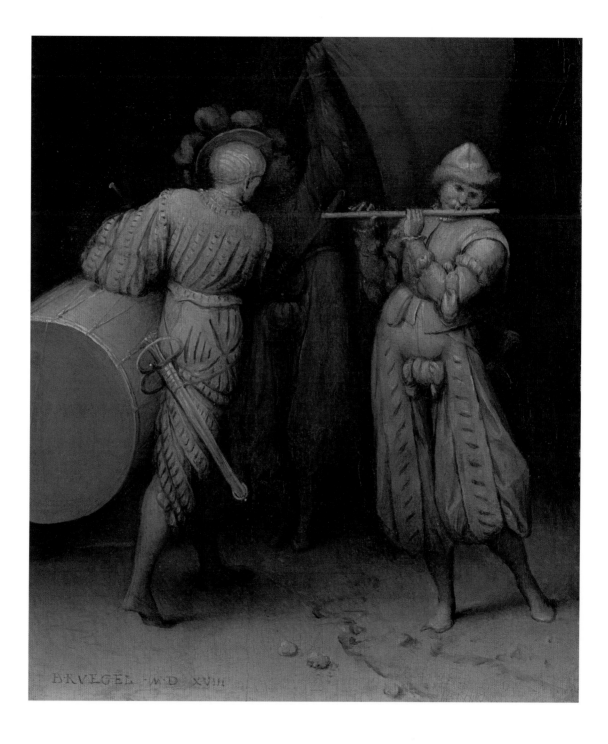

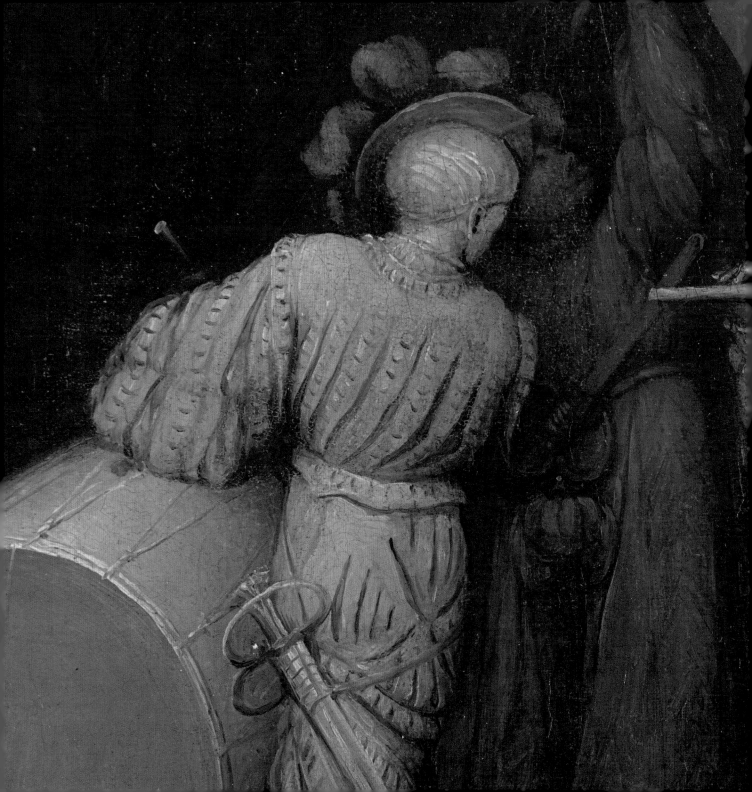

times of conflict and dangerously roamed the country, disaffected, during times of peace. Symbols of the political and religious unrest of the time, they were a familiar sight in the Southern Netherlands in Bruegel's day. The subject-matter of *Three Soldiers* thus had a topical resonance for Bruegel, although the mercenaries were not identified with a specific faction. Such figures were also widely perceived as outsiders, much like beggars or gypsies, also depicted by Bruegel.

The trio composed of a standard-bearer, a drummer and a fifer was a favoured motif within the vast output of prints representing mercenary soldiers. The three figures played an important symbolic role within the regiment: the standard-bearer, second only to the commander, rallied the soldiers around the unit's flag while the musicians kept spirits up when going into battle.[3] An immediate source for Bruegel could have been an engraving by the earlier Netherlandish master Allaert Claesz. (fig. 17). The two compositions are closely related: a standard-bearer, represented frontally, stands in the centre of the composition. He is flanked on the left by a drummer who turns his back to the viewer and, on the right, by a fifer. The figures sport the same slashed doublets, fancy hats and short swords that characterise the *Landsknechte*. Interestingly, the only difference resides in the men's hose. In the print, these are short and tied at the knee, while the voluminous hose represented by Bruegel came into fashion only in the second half of the century, indicating that Bruegel may have brought these prints up to date and drawn his inspiration from life. He may have been equally aware of later prints depicting military men sporting the latest fashion, as the subject-matter continued to prove popular (fig. 18).

It is unclear, however, what kind of moment or event the painter has chosen to depict. The rocks on the ground imply

16

Jacob Binck
A standard-bearer, a piper and a drummer, mid 16th century
Engraving, 5.9 × 4.5 cm,
The British Museum, London

17
Allaert Claesz. (below)
*A standard-bearer flanked by a soldier
playing on a drum with a snare, and
another playing the flute*, c. 1520-50
Engraving, diameter 5.5 cm
The British Museum, London

18
Virgil Solis
A group of five Landsknechte, c. 1530–62
Etching and engraving, 7.2 × 12.7 cm
The British Museum, London

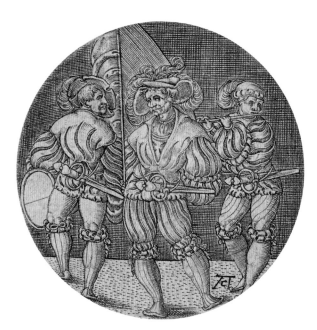

an outdoor setting but, as in *Christ and the Woman Taken
in Adultery*, no sense of place is given. Are we witnessing a
training exercise, or the moment of departure for battle,
as the standard-bearer raises the flag? The figures certainly
convey no sense of menace. Equally unclear is the basis for
Bruegel's deciding to depict the scene in grisaille. As Peter
van der Coelen has noted, the decision to represent these
colourful and extravagant figures in black and white appears
slightly puzzling.[4] Bruegel's engagement with the art of the
past and with prints can partly explain this choice, as does
his magisterial demonstration of painterly skill, capable of
evoking a variety of brash colours through the simple use
of grey tonalities.

This small panel, signed and dated to the year before
Bruegel's death,[5] reappeared only half a century ago and
has not been widely discussed in the Bruegel literature. In
contrast to the two other grisailles, no copies or prints after
it exist and thus its composition was not known before the
reappearance of the original. The Frick panel must, however,
be included in Bruegel's corpus, given its close similarity
in technique with the other two known grisailles and its
identification with a panel from Charles I's collection in
the second quarter of the seventeenth century.

Three Soldiers is painted on a single wooden panel that
has not been cut down.[6] As in the case of the other grisailles,
infrared examination has revealed a thorough and lively

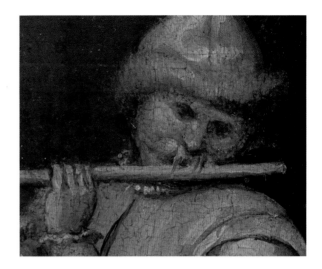

underdrawing in a dry black medium on the white ground. A number of small changes from the underdrawing to the finished painting can be noted, most especially the ellipse of the drum and the feet of the fifer.

The background was painted black, and reserves left only for the two musicians in the foreground. Like the four main figures in *Christ and the Woman Taken in Adultery*, they were painted directly on the white ground with thin layers of grey, which endows them with a greater luminosity. In contrast, the standard-bearer, painted over the black background, is much more difficult to discern. The virtuoso handling of paint and swift brushstrokes are as confident as in the other two grisailles: several passages use the still plastic paint to create original effects, such as the three marks made by dragging the wet paint over the fife to give a sense of the soldier's thick moustache falling over his instrument (fig. 19).[7] Both the ground and the varnish have discoloured, giving the painting its overall – albeit unintentional – warm beige tone. It would have originally had a much cooler tonality.

Although the panel has remained unknown for most of the past three centuries, it can be linked to an early inventory, and indeed one of the most prestigious. As the inventory of Charles I's collection attests, the panel was in the British royal collection by 1640. Mistaking the *Landsknechte* for Swiss mercenaries, the inventory describes "A Peece of three Switz little entire figures, being an Auntient [ensign], A drummer, and a ffluter done by old Peter Brewgill given by Mr Endimion Porter, in blacke and white".[8] It is possible that Endymion Porter acquired the work during a diplomatic mission to the Netherlands undertaken in 1634–35 on behalf of Charles I. In addition to acting as the king's envoy to the new governor of the Spanish Netherlands, Porter had also been instructed to

purchase paintings by Van Dyck and Rubens for the royal collection. Bruegel would have been an equally prestigious acquisition. However, the crowned CP (Carolus Princeps) branded on the reverse of the panel suggests that it entered Charles's collection before his ascension to the throne in 1625.

Following his execution in 1649, the painting was sold during the Commonwealth sales. On 1 February 1652, "A drum and fife … in black and white" was acquired for £5 by "T. Greene".[9] The panel was returned to the royal collection at the Restoration and was last recorded in a storeroom at Kensington Palace upon the death of Queen Anne in 1714: "Brugle. 167. A long and Narrow piece a man beating a Drum w[th] Sev[era]l fig[ure]s".[10] How it left the royal collection and entered that of William van Huls, who was private secretary to William III, is unknown. However, the panel's slow demotion from the king's privy gallery to a storeroom at Kensington Palace to leaving the royal collection altogether is indicative of Bruegel's critical fortunes.[11] KS

9

ATTRIBUTED TO JAN BRUEGHEL THE ELDER (1568–1625)

The Visit to the Farm, c. 1600

Oil on panel, 28.5 × 42.7 cm
Fondation Custodia, Lugt Collection, Paris, inv. no. 431

Provenance: Purchased by Frits Lugt (1884–1970), Paris, from the dealer Henri
Grosjean-Maupin on 11 January 1920; Fondation Custodia, Paris

This large panel was purchased by Lugt as a rare grisaille
by Pieter Bruegel the Elder, although it has since been
recognised that the handling of paint lacks the fluidity and
swiftness that characterise his other monochrome works.[1]
The delicate modelling, heavily reliant on outlines with the
addition of localised highlights with thin strokes of white
paint, is reminiscent of Jan Brueghel's copy after *Christ
and the Woman Taken in Adultery* (cat. 5) and points to his
authorship, as do the treatment of the figures' deep-set eyes.
Another, slightly larger, grisaille of the same composition
is held in the Koninklijk Museum voor Schone Kunsten in
Antwerp and has long been attributed to Jan.[2]

This composition was one of the most frequently copied
by Jan, as well as by Pieter the Younger and his workshop:
more than two dozen colour copies are known.[3] The well-
dressed couple on the right, accompanied by a lady in the
background, has been identified as a wealthy landowner
and his wife visiting one of his tenant farmers following
the birth of his child. As the landowner hands his tenant a
gift (possibly a sugarloaf), his wife reaches in her purse for
a coin to give to the pleading eldest child. A bulky fuming
cauldron at the centre takes up much of the space in the
small and busy dwelling.

Many elements of the design, notably the peasant interior,
the round table, the nursing mother and the toddler dressed
in a long shirt, echo Pieter Bruegel's lost drawing of *The
Poor Kitchen* (known thanks to the print by Pieter van der
Heyden). However, the question remains as to whether
Jan borrowed a number of motifs to create a pastiche or
if indeed Bruegel's sons were copying a lost composition
by their father. KS

10

FRANS POURBUS THE ELDER (1545–1581)

The Last Supper, c. 1570

Oil on paper mounted on canvas, 41.3 × 56 cm
Signed on the crossbar of the bench on the lower left : *F. Pourbus Inv 15*
Musée des Beaux-Arts, Caen, inv. no. 66.1.1

Provenance: Purchased by the museum on the art market in Paris in 1966

Active in Antwerp in the third quarter of the sixteenth century, Pourbus left a small oeuvre composed principally of portraits. Religious scenes by him are rare, although he received a number of commissions for altarpieces, several of which had their outer wings painted in grisaille (Saint George Altarpiece, Musée des Beaux-Arts de Dunkerque; Saint Martin Altarpiece, Seminary, Tournai).

This work on paper representing *The Last Supper* and executed in grisaille was long considered a preparatory sketch, or *modello*, for a larger composition or an engraving. However, its size, level of finish and signature call this into question. Like Bruegel's grisaille drawing of *The Resurrection* (fig. 4), it is likely that Pourbus created it as an autonomous work of art, destined for a collector's cabinet.[1]

The composition bears some relation to a *Last Supper* (1562; Onze Lieve Vrouwekerk, Bruges) by Frans's father, Pieter (1523/24–1584). This shows the same blessing Christ, the two figures seated on a bench at the end of the table and the Apostle rising from his stool in the foreground. However, it lacks the dramatic foreshortening of the table present in Frans Pourbus's representation, which was probably influenced by the artist's study of Venetian models. KS

NOTES TO THE CATALOGUE

References appearing in the notes more than once are given in short form; full details appear in the bibliography at the end of the volume.

CAT. 1

1 In referring to the engraving, Hulin de Loo, co-author of the first great monograph on Bruegel, raised the idea of an original painting by Bruegel, although it had not yet been rediscovered. He had deduced that the engraving had been executed in the same orientation as the painting, observing that the statue of the warrior saint on the chimneypiece held his sword in his right hand: Bastelaer and Hulin de Loo 1907, p. 364. After the rediscovery of the Upton House grisaille, Michel (1931) and Tolnay (1935) remained hesitant about its authorship. However, the work has been unanimously upheld by subsequent scholarship as the original by Bruegel.

2 Burchard 1930 and Glück 1930.

3 Denucé 1932, pp. 56–71, esp. p. 64 (no. 193: "Het Sterven van Ons Lieve Vrouwe, wit en swart, door den ouden Breugel"); Allart 2001–02, p. 50, doc. 21, and p. 53. The painting may have belonged to Rubens's first wife, Isabella Brant: E. Duverger, *Antwerpse kunstinventarissen uit de zestiende eeuw*, 1984–89, vol. 4, p. 297 (no. 193). See also Michael Jaffé, 'Rubens and Bruegel', in *Pieter Bruegel und seine Welt*, ed. Otto von Simson and Matthias Winner, Berlin 1979, pp. 37–42, esp. pp. 37–39.

4 Stevens cited various paintings in his possession or owned by other collectors: see Jan Briels, '*Amator Pictoriae Artis*. De Antwerpse kusntverzamelaar Peeter Stevens (1590–1668) en zijn Constkamer', *Jaarboek Koninklijk Museum voor Schone Kunsten Antwerpen*, 1980, pp. 137–226, esp. pp. 194–201 and 206; Allart 2001–02, p. 49, doc. 16, and p. 53.

5 Denucé 1932, p. 355: "n° 19: *Pineel den Sterffdach van onse lieve Vrouwe Breugel* [sic]"; Marlier 1969, p. 95. Burchard 1930 was mistaken in believing that the estimation was high. In fact, the value of the Bruegelian works in this collection ranges between 36 and 800 florins.

6 Bruegel could have been aware of Dürer's version of *The Death of the Virgin* through Ortelius, who was an ardent collector of Dürer's prints: see Buchanan 1982. On other possible sources of Bruegel's compositions in Netherlandish art of the fifteenth and early sixteenth centuries, see principally Urbach 1978.

7 Christ and the angels are also absent in the versions of the theme by Joos van Cleve (Wallraf-Richartz-Museum, Cologne, and Alte Pinakothek, Munich). Like Schongauer and Dürer, Van Cleve represents the Virgin receiving the taper from John, not Peter.

8 Reproduced in Gibson 1977, ill. 94; discussed in Urbach 1978, p. 240.

9 Glück 1930, p. 285.

10 Glück 1930 had already put forward this interpretation. See also Urbach 1978, pp. 246–50: for this author, "nothing indicates than the sleeping young man is St John" (p. 248). She points to occurrences of a sleeping figure in *The Death of the Virgin* by Petrus Christus (c. 1460–65; Timken Art Gallery, San Diego) and in the Death of the Virgin Triptych by Bernard van Orley (1520; Musée de l'Assistance publique, Brussels). See also Melion 1996, who seems unaware of Urbach's study and largely bases his overall interpretation of the work on the premise that the sleeping person is Saint John.

11 This version forms the third part of the accounts of the Death of the Virgin compiled by Jacobus: Barbara Fleith, 'De Assumptione Beatae Virginis Mariae. Quelques réflexions autour du compilateur Jacques de Voragine', in Barbara Fleith and Franco Morenzoni, *De la sainteté à l'hagiographie : genèse et usage de la Légende dorée*, Geneva, 2001, pp. 41–74, esp. pp. 46–50 (with bibliography). The only scholar who connected the crowd with the correct part of Jacobus's text was Urbach 1978, p. 244.

12 On the basis of another tradition also related by Jacobus de Voragine, certain commentators have suggested that the assembled group were Patriarchs, martyrs, confessors and holy virgins who would accompany Christ at the moment of Mary's death. Melion 1996, p. 19, rightly demonstrates that this interpretation is unconvincing.

13 See, for example, René Boumans, 'The Religious Views of Abraham Ortelius', *Journal of the Warburg and Courtauld Institutes*, XVII, 1954, pp. 374–77, and Herman De la Fontaine-Verwey, 'The Family of Love', *Quaerendo*, vol. 6, no. 3, 1976, pp. 219–71. The most nuanced and convincing account of the religious positions of Bruegel and Ortelius is given by David Freedberg: 'Allusion and Topicality in the Work of Pieter Bruegel: The Implication of a Forgotten Polemic' 1989, pp. 53–65, in *The Prints of Pieter Bruegel the Elder* 1989, pp. 53–65. On Ortelius, see Karrow 1998.

14 The technical study was carried out by Christina Currie and Ruth Bubb in May 2014, and we remain grateful to the National Trust staff, in particular Christine Sitwell, Michelle Leake and Julie Marsden. In 2004, the painting had been studied at the National Gallery, London, by Lorne Campbell and Rachel Billinge, who kindly shared their unpublished findings. For a short summary, see Campbell 2005, esp. pp. 36–37.

15 The panel, which still displays its original thickness of 6–7 mm, has a slight convex warp and two minor cracks near the bottom edge. These cracks are supported by six rectangular oak buttons applied to the reverse of the painting.

16 All details are reproduced here with kind permission of Ian Tyers from his unpublished

report: 'Tree-Ring Analysis of Two Brueghel Panel Paintings from the National Trust's Upton House Collection. Dendrochronology Consultancy Report 690', May 2014.

17 Currie and Allart 2012, I, pp. 184–223. We thank Pascale Fraiture (KIK-IRPA, Belgium). We do not know whether Bruegel had his panels made in-house or whether he bought them from an independent panel-maker.

18 We thank Ian Tyers for allowing us to cite this new discovery from his unpublished report: 'Tree-Ring Analysis of Three Panels from the Courtauld Gallery. Dendrochronology Consultancy Report 807', November 2015.

19 On Bruegel's preparatory layers, see Currie and Allart 2012, I, pp. 249–59.

20 We are grateful to Aviva Burnstock for suggesting this possibility.

21 The infrared reflectogram was made by Tager Stonor Richardson using an Osiris infrared reflectography camera (sensor: InGaAs array, operation wavelength: 0.9-1.7 microns).

22 This was first noted by Lorne Campbell and Rachel Billinge in 2004 on the basis of microscopic examination; they suggest that smalt and azurite might both be present (no pigment analysis has been carried out on the painting to date).

23 Lorne Campbell and Rachel Billinge already noted modifications made to the Virgin's attendant, the cat and the bed in their technical study of 2004.

24 Gore 1964, p. 44. Unpublished expert opinions from 1928–29 kept in the Lee archives at The Courtauld Institute of Art all mention a clear signature but no date.

25 For illustrations and discussion of fingerprints in Bruegel's paintings and references to other artists using their fingers as a tool in painting, see Currie and Allart 2012, I, pp. 310-13.

26 This was an allusion to the celebrated ancient Greek painter Timanthes who, as Pliny the Elder reported, depicted Agamemnon's grief at the sacrifice of his daughter Iphigenia by veiling his face rather than painting his tears. See Jean Puraye (ed.), 'Abraham Ortelius. Album Amicorum', *De Gulden Passer*, vols. 45–46, 1967–68, pp. 21–22; Muylle 1981, pp. 319–37, and *The Prints of Pieter Bruegel the Elder* 1989, pp. 53–65. On Ortelius's interest in the arts, see principally Popham 1931; Buchanan 1982; Nils Büttner, 'Abraham Ortelius comme collectionneur', in Karrow 1998, pp. 168–80, esp. pp. 174–75, and Tine Luk Meganck, *Erudite Eyes. Artists and Antiquarians in the Circle of Abraham Ortelius (1527–1598)*, PhD dissertation, Princeton University, 2003, esp. pp. 190–221.

27 Illustrations of four of the five known painted copies were consulted: (1) oil on copper, 29.5 × 43 cm, signed *P. BREVGHEL*, formerly Brussels, private collection, sold at Campo, Antwerp, 3–5 December 1974, lot 195 (as Pieter Brueghel the Younger); (2) oil on copper, 28.5 × 42 cm, sold at Lempertz, Cologne, 14 May 1994, lot 364 (as Jan Brueghel the Younger); (3) oil on panel, 31.5 × 44.5 cm, sold at Christie's, Amsterdam, 21 May 1985, lot 151 (as circle of Frans Francken II after Pieter Bruegel the Elder); (4) oil on panel, 49 × 65.5 cm, sold at Sotheby's, New York, 25 November 1981, lot 36 (as school of Pieter Bruegel the Elder). For illustrations of the above, see Marlier 1969, p. 94, and Ertz 1998–2000, nos. A438–41. A fifth, large-format version was not seen in reproduction: (5) oil on panel, 89 × 111 cm, Edouard Fétis sale, Brussels, 9 November 1909, no. 11 (Marlier 1969, p. 94, and Ertz 1998–2000, no. F438).

28 During the year 1616, Pieter Brueghel the Younger changed the 'VE' in the spelling of his signature to 'EV', which helps date his paintings: Ertz 1998–2000, I, p. 20, and Currie and Allart 2012, I, pp. 79–81.

CAT. 2

1 *The Prints of Pieter Bruegel the Elder* 1989, no. 88, and *Pieter Bruegel the Elder. Drawings and Prints* 2001, no. 117.

2 Manfred Sellink and Marjolein Leesberg, *The New Hollstein. Dutch and Flemish Etchings, Engravings and Woodcuts, 1450–1700. Philips Galle, Part I*, Rotterdam, 2001, p. xlii. See also *Pieter Bruegel the Elder. Drawings and Prints* 2001, no. 117.

3 "*Dye camer sceen doodlyc, noch docht my leefdet al*", quoted in Hessels 1887, pp. 175–78, letter 75, and Muylle 1981, p. 329, n. 34.

4 "*Dexterissime et valde pie depictam*", quoted in Hessels 1887, pp. 427–29, letter 177. Montanus evidently had seen the picture before, since he underlined its qualities. On the letter dated 30 March 1590, see Hessels 1887, p. 471. On later exegeses of the composition in the wake of the Council of Trent, see Melion 1996.

5 It is signed *Breughel Fixit* on the cross-bar of the table and dated *1540* on the chest. It once belonged to Everard Jabach (1610–1695) and was sold to Louis XIV in 1671.

6 Kristin Lohse Belkin, *Corpus Rubenianum, Part XXVI. Copies and Adaptations from Renaissance and Later Artists*, I. *German and Netherlandish Artists*, Turnhout and London, 2009, no. 94, pp. 199–200.

7 Jaffé and Belkin both claim that Rubens retouched the drawing.

CAT. 3

1 Handwritten marginal notes in Stevens's copy of Karel van Mander's *Schilderboeck* in the Biblioteca Hertziana, Rome: "a white and black little piece with the adulterous woman".

2 Described as "Breugel le vieil, La femme adultère, jadis une Piece du Cabinet du R.P. Frederic … Archeveque de Milan".

3 The painter was sometimes too swift: he endowed Christ with six fingers on his right hand. This error was rectified by all subsequent copyists, including the engraver Perret.

4 Ian Tyers, 'Tree-Ring Analysis of Three Panels from the Courtauld Gallery. Dendrochronology Consultancy Report 807', November 2015.

5 It is unclear if the drawing was made in a fluid medium or dry one, such as red chalk, that was then wet by the overlying paint.

6 Grossman 1952, p. 225, illustrated the painting now in Frankfurt but the earlier version seems a closer match.

7 See Walter S. Melion, 'Introduction: Visual Exegesis and Pieter Bruegel's Christ and the Woman Taken in Adultery', in Walter S. Melion, James Clifton and Michel Weemans (eds.), *Imago Exegetica: Visual Images as Exegetical Instruments, 1400–1700*, Leiden and Boston, 2014, pp. 1–41 (with previous bibliography).

8 Grossmann 1973b, Gibson 1977, pp. 137–40, and Sellink 2011, p. 214. A pastiche conflating figures from both sides of the composition was even recently attributed to an Italian artist, the Bolognese painter and sculptor Amico Aspertini, without reference to Bruegel: Antonio Storelli, 'Amico Aspertini. *Disputa*', in *Amico Aspertini, 1474-1552: artista bizzarro nell'età di Dürer e Raffaello*, Andrea Emiliani and Daniela Scaglietti Kelescian (eds.), Pinacoteca Nazionale di Bologna, 2008-09, no. 12, pp. 106-07, mentioned by Paolo Plebani in *Riscoprire la Carrara* 2014, p. 136.

9 Grossmann 1973b.

10 Allart 2001-02.

11 Crivelli 1868, pp. 339–46.

12 Jones 1993, p. 240.

13 Marlier 1969, pp. 88–92.

14 Every 1.6 cm on the horizontal, every 0.8 cm on the vertical.

15 Tate-Harte 2006, p. 40.

CAT. 4

1 First suggested by Grossmann 1952, p. 221.

CAT. 6

1 Crivelli 1868, p. 119.

2 Crivelli 1868, p. 339–41.

3 Jones 1993, pp. 138–39 and 146–47.

4 Jones 1993, p. 240 (the copy is described as lost). Local painters that were known to make copies for Borromeo include Antonio Mariani and Agostino Decio.

CAT. 7

1 Sutton 2002, pp. 74–77.

2 Marlier 1969 and Ertz 1998–2000, pp. 380–86.

CAT. 8

1 For help with provenance research, I am most grateful to Lucy Whitaker and Nikolai Munz from the Royal Collection Trust, and Rachael Merrison at the National Gallery archives.

2 For representations of soldiers in German art, see Hale 1990, pp. 1–34 and 52–68; Morrall 2002 and *De ontdekking van het dagelijks leven* 2015–16, pp. 117–23.

3 See Douglas Miller, *The Landsknechts*, London, 1979. The standard-bearer was paid five times more than the foot soldiers, in recognition of his symbolic and strategic role.

4 *De ontdekking van het dagelijks leven* 2015–16, p. 229.

5 The L is severely abraded and almost invisible now.

6 An extensive examination of the painting was undertaken in July 2015 by Sophie Scully at the Sherman Fairchild Center for Paintings Conservation at the Metropolitan Museum of Art, at the request of The Frick Collection.

7 Noted by Sophie Scully.

8 Millar 1958–60, p. 223; see also no. 36, p. 69 (listed in the "King's Chare Room in the privy Gallery" in Whitehall: "Done by y[e] young Brugill, Given to the king by [blank]/Item painted in black and white oyle Cullo[rs] upon a board, Three sweets [Swiss] A Drummer A fffe and an Aunciannt in and all over/gilded frame").

9 Millar 1970–72, p. 259: the work was recorded in St James's Palace in 1649 and later brought to Somerset House to be sold. There is another mention of a painting by Bruegel, this one with four soldiers (p. 190): "4 sould[rs] done by old Breugell: at/Sold to Latham a/o 23 October 1651, [£]20:00:00".

10 It was previously recorded "in the King's Great Closett" (Whitehall?) under James II: see Andrew Barclay, 'The inventories of the English royal collection, temp. James II', *Journal of the History of Collections*, 22, no. 1, 2010, pp. 1–13, and online supplement no. 144: "A Small painting in black and white, being an Ensigne, A Drummer and a fffe, Swissers".

11 See Campbell 1985, pp. xliii–xliv.

CAT. 9

1 Only Alexander Wied in *Pieter Bruegel d. Ä. Beiheft* 1997-98 has maintained the attribution to Pieter Bruegel the Elder.

2 Ertz 2008–10, III, p. 1244.

3 Ertz 1998–2000, pp. 474–86.

CAT. 10

1 See Françoise Debaisieux, *Caen. Musée des Beaux-Arts. Peintures des écoles étrangères* (*Inventaire des collections publiques françaises, n° 36*), Paris and Caen, 1994, pp. 270–71.

SELECTED LIST OF WORKS CITED

PRIMARY AND SECONDARY SOURCES

(in alphabetical order):

Dominique Allart, 'Did Pieter Brueghel the Younger see his Father's Paintings? Some Methodological and Critical Reflections', in *Brueghel Enterprises*, exh. cat., ed. Peter van den Brink, Bonnefantenmuseum, Maastricht, and Musées Royaux des Beaux-Arts de Belgique, Brussels, 2001–02, pp. 46–56

René van Bastelaer and Georges Hulin de Loo, *Peter Bruegel l'Ancien: son œuvre et son temps*, Brussels, 1907

Iain Buchanan, 'Dürer and Abraham Ortelius', *The Burlington Magazine*, CXXIV, December 1982, pp. 734–41

Ludwig Burchard, 'Pieter Bruegel the Elder (around 1529–1569), *The Death of the Virgin*', in Wilhelm Reinhold Valentiner (ed.), *Unknown Masterpieces in Public and Private Collections*, London, vol. 1, 1930, p. 40

Lorne Campbell, *The Early Flemish Pictures in the Collection of Her Majesty the Queen*, London, 1985

Lorne Campbell, 'Reflections on Sources and Reconstructions', in Mark Clarke, Joyce H. Townsend and Ad Stijnman (eds.), *Art of the Past, Sources and Reconstructions. Proceedings of the First Symposium of the Art Technological Source Research Study Group*, London and Amsterdam, 2005, pp. 33–38

Giovanni Crivelli, *Giovanni Brueghel pittor fiammingo, o Sue lettere e quadretti esistenti presso l'Ambrosiana*, Milan, 1868

Christina Currie and Dominique Allart, *The Brueg(H)el Phenomenon. Paintings by Pieter Bruegel the Elder and Pieter Brueghel the Younger with a Special Focus on Technique and Copying Practice*, 3 vols., Brussels, 2012

Jean Denucé, *The Antwerp Art-Galleries. Inventories of the Art-Collections in Antwerp in the 16th and 17th Centuries*, Antwerp, 1932

Klaus Ertz, *Pieter Brueghel der Jüngere (1564–1637/38). De Gemälde mit kritischem Oeuvrekatalog*, 2 vols., Lingen, 1998–2000

Klaus Ertz and Christa Nitze-Ertz, *Jan Brueghel der Ältere (1568–1625). Kritischer Katalog der Gemälde*, 4 vols., Lingen, 2008–10

Walter S. Gibson, *Bruegel*, New York and Toronto, 1977

Gustav Glück, 'A Newly-Discovered Painting by Pieter Brueghel the Elder', *The Burlington Magazine*, LVI, 1930, pp. 284–86

Gustav Glück, *Brueghels Gemälde*, Vienna, 1932

F. St John Gore, *Upton House, The Bearsted Collection: Pictures*, National Trust, 1964

Fritz Grossmann, 'Bruegel's "Woman Taken in Adultery" and Other Grisailles', *The Burlington Magazine*, XCIV, no. 593, August 1952, pp. 218–27

Fritz Grossmann [1973a], *Bruegel. The Paintings. Complete Edition*, 3rd edn, London, 1973

Fritz Grossmann [1973b], 'Notes on Some Sources of Bruegel's Art', *Album amicorum J.G. van Gelder*, The Hague, 1973, pp. 147–58

J.R. Hale, *Artists and Warfare in the Renaissance*, New Haven, 1990

Jan Hendrik Hessels, *Abrahami Ortelii (geographi Antwerpiensis) et virorum eruditorum ad eundem et ad Jacobum Colium Ortelianum (Abrahami Ortelii sororis Filium)*, Canterbury, 1887

Pamela M. Jones, *Federico Borromeo and the Ambrosiana. Art Patronage and Reform in Seventeenth-Century Milan*, Cambridge, Mass., 1993

Robert W. Karrow (ed.), *Abraham Ortelius (1527–1598), cartographe et humaniste*, Turnhout, 1998

Eckhard Leuschner, 'A Grisaille Oil Sketch from the "De Backer Group" and Workshop Practices in Sixteenth-Century Antwerp', *The Metropolitan Museum Journal*, vol. 43, 2008, pp. 99–110

Roger Marijnissen, *Bruegel, Tout l'œuvre peint et dessiné*, Antwerp, 1988

Georges Marlier, *Pierre Brueghel le Jeune*, Brussels, 1969

Walter S. Melion, '"Ego enim quasi obdormivi": Salvation and Blessed Sleep in Philips Galle's Death of the Virgin after Pieter Bruegel', *Nederlands Kunsthistorisch Jaarboek*, 47, no. 1, 1996, pp. 14–53

Edouard Michel, *Bruegel*, Paris, 1931

Oliver Millar, 'Abraham van der Doort's Catalogue of the Collections of Charles I', *Walpole Society*, XXXVII, 1958–60

Oliver Millar, 'The Inventories and Valuations of the King's Goods, 1649–1651', *Walpole Society*, XLVII, 1970–72

Andrew Morrall, 'Soldiers and Gypsies: Outsiders and their Families in Early Sixteenth-Century German Art', in Pia Cuneo (ed.), *Artful Armies, Beautiful Battles. Art and Warfare in Early Modern Europe*, Leiden, Boston and Cologne, 2002, pp. 159–80

Jan Muylle, 'Pieter Bruegel en Abraham Ortelius, Bijdrage tot de literaire receptie van Pieter Bruegels werk', in Maurits Smeyers (ed.), *Archivum Artis Lovaniense. Bijdragen tot de geschiedenis van de kunst der Nederlanden opgedragen aan Prof. Em. Dr. J.K. Steppe*, Leuven, 1981, pp. 319–37

A.E. Popham, 'Pieter Brueghel and Abraham Ortelius', *The Burlington Magazine*, LIX, 1931, pp. 184–88

Manfred Sellink, *Bruegel. The Complete Paintings, Drawings and Prints*, Antwerp, 2011

Larry Silver, *Pieter Bruegel*, New York and London, 2011

Peter C. Sutton, *Dutch and Flemish Paintings: The Collection of Willem, Baron van Dedem*, London, 2002

Alice Tate-Harte, *The Technique and Function of* Christ and the Woman Taken in Adultery; *a Grisaille Painting by Peter Bruegel the Elder*, unpublished final year research project for the Postgraduate Diploma in the Conservation of Easel Paintings, The Courtauld Institute of Art, London, 2006

Charles de Tolnay, *Pierre Brueghel l'Ancien*, Brussels 1935

Zsuzsa Urbach, 'Notes on Bruegel's Archaism. His Relation to Early Netherlandish Painting and Other Sources', *Acta Historiae Artium*, vol. 24, 1978, pp. 237–56

EXHIBITION CATALOGUES

(in chronological order):

Gray is the Color. Catalogue of an exhibition of grisaille painting, XIIIth–XXth centuries, ed. J. Patrice Marandel, Rice Museum, Houston, 1973–74

Bruegel. Une dynastie de peintres, Palais des Beaux-Arts, Brussels, 1980

The Prints of Pieter Bruegel the Elder, ed. David Freedberg, Bridgestone Museum of Art, Tokyo; Prefectural Museum of Art, Hiroshima; Ishibashi Museum of Art and Prefectural Art Museum, Mie, 1989

Pieter Bruegel d. A. Beiheft: ergänzenden Leihgaben zur Ausstellung im Kunsthistorisches Museum, Wien, ed. Alexander Wied, Kunsthistorisches Museum, Vienna, 1997–98

Pieter Bruegel the Elder. Drawings and Prints, ed. Nadine M. Orenstein, The Metropolitan Museum of Art, New York, and Museum Boijmans Van Beuningen, Rotterdam, 2001

Bosch and Bruegel. Inventions, Enigmas and Variations, by Lorne Campbell, National Gallery, London, 2004

Pas la couleur, rien que la nuance! Trompe-l'œil et grisailles de Rubens à Toulouse-Lautrec, by Axel Hémery, Musée des Augustins, Toulouse, 2008

Jan van Eyck: Grisallas, ed. Till-Holger Borchert, Museo Thyssen-Bornemisza, Madrid, 2009–10

Brueghel. Gemälde von Jan Brueghel d. Ä., ed. Mirjam Neumeister, Alte Pinakothek, Munich, 2013

Riscoprire la Carrara. Mantegna, Bellini, Raffaello e Moroni. Restauri e capolavori in dialogo, ed. M. Cristina Rodeschini, Accademia Carrara, Bergamo, 2014

De ontdekking van het dagelijks leven. Van Bosch tot Bruegel, ed. Peter van der Coelen and Friso Lammertse, Museum Boijmans Van Beuningen, Rotterdam, 2015–16

PHOTOGRAPHIC CREDITS